# TOUCHING STRANGERS

# RICHARD RENALDI
## TOUCHING STRANGERS
### INTRODUCTION BY TEJU COLE

aperture

Passing stranger! you do not know how longingly I look upon you,

You must be he I was seeking, or she I was seeking, (it comes to me as of a dream,)

I have somewhere surely lived a life of joy with you,

All is recall'd as we flit by each other, fluid, affectionate, chaste, matured,

You grew up with me, were a boy with me or a girl with me,

I ate with you and slept with you, your body has become not yours only nor left my body mine only,

You give me the pleasure of your eyes, face, flesh, as we pass, you take of my beard, breast, hands, in return,

I am not to speak to you, I am to think of you when I sit alone or wake at night alone,

I am to wait, I do not doubt I am to meet you again,

I am to see to it that I do not lose you.

Walt Whitman, "To a Stranger," *Leaves of Grass* (1881 edition)

# INTRODUCTION BY TEJU COLE

A photograph is a two-dimensional object, nothing but surface. On this surface is presented, with areas of dark and light and sometimes color, an illusion of narrative depth. We know that abstraction is possible in photography, as is manipulative postprocessing, but in the case of most unaltered photos — landscapes, portraits, photojournalism — we rightly assume that the photograph's relationship with life is straightforward. We take it on trust that things are as they seem. These viewing habits, which serve us so well in most cases, make us tense and interested when we look at Richard Renaldi's photographs in *Touching Strangers.*

The portraits in this book each came about in a similar fashion. In a public place in one or another American city or town, Renaldi asked a stranger to allow his or her photograph to be taken. Another stranger was then asked to pose with the first stranger, and the pair were photographed together, not simply in terms of occupying the same frame, but in close physical proximity to each other. Often these strangers had to be cajoled by the photographer to hold each other, to embrace, to touch. The photos are not first takes. It took time to get the right closeness and an interesting-enough interaction between the strangers. Sometimes the number of subjects was three, or four. Some of the latter, the quadruple portraits, can only be described as "family photographs": we have no other vocabulary other than the familial for images like those on p. 18 and p. 54, which show a man, a woman, and two children posed in a close group.

When we sit at a café or in a restaurant, we pretend to be wholly focused on our food and our companions, but we spend some of our time imagining the lives of the people around us all the time. Those two men holding hands a few tables over: how long have they been together? Why is the woman at that table over there crying quietly into her napkin? What will the suspiciously older man seated with her do about it? Is he her father or her lover? And the anxious woman who has been alone at the bar for a while now: what's happening with her? Has her date stood her up? Or is that her job, to wait until some generous stranger takes interest? We

do this habitually, making up stories about other people, and at the same time, they are certainly making up stories about us. Stories of these kinds — stories about love and about the uncertainties between people — are the kinds of stories suggested by the portraits in *Touching Strangers*.

"Fine photography is literature," Walker Evans wrote, "and it should be." The narrative force in Renaldi's fine pictures comes out of the way their calm surfaces suddenly open out to the most intense and troubling themes of contemporary life. It is possible to imagine this idea deployed in a less successful way: quick snapshots of strangers smiling together, a sentimental record of a walk down a crowded street, with no great insight or resonance in the resulting pictures. Something quite different happens in Renaldi's pictures. His subjects have the soulfulness and seriousness of the people August Sander photographed in Germany between 1910 and 1950. But unlike Sander's subjects, who were photographed in their ease, Renaldi's have been asked to briefly subvert their expectations about personal space and public propriety. In their bodies we read a large number of silent signals, often more than one present in each person: performance, tension, submission, affection, rigidity, unhappiness, comedy, sexuality, embarrassment, boredom, relief.

Any society is governed by the invisible perimeter fence of its taboos. Benign touch from a stranger is allowed when permission is granted and, usually, when some service is performed: at the doctor's office, at the barber shop, at the masseuse or the tailor. But intimate touch of the romantic kind is permitted not only by the mutual consent of adults, but controlled by laws and prejudices. We are still within living memory of the *Loving v. Virginia* case, when a black woman and a white man had to fight the state for the legal right to marry. In a historical sense, 1967 is not long ago. Meanwhile, in linguistic terms, "touching" is not uncomplicated. Earlier eras used it to mean "concerning," and this sense is present secondarily in Renaldi's title: it is a book concerning strangers and their interactions with each other. But the word is now

also a euphemism for various forms of inappropriate contact: "touching children" is a crime, and "touching oneself" is not a subject for polite company. On the positive side of the ledger, we might think of the many stories of the healing touch: the power of the laying-on of hands is a trope common to many religions. And science assents: monkeys that are touched and held in infancy do better, healthwise, than those that are deprived of maternal touch. Research on humans indicates that hugs release therapeutic endorphins and serotonin, and increase one's sense of well-being.

The portraits in Renaldi's book are situated in this terrain of taboos and consolation. In the silence between his subjects, there's a charge. How do we feel when we see two men of such different sartorial instincts as David and Claudio (p. 25) being tender with each other? What about a black man in hip-hop clothes getting up close and personal with a white woman in a wedding dress (p. 29)? We can quickly get past some of these — we prefer to believe that such unseemly bias is in other people, not in us. But why does the unease remain when we view an image like the one on p. 75, which shows Nathan, a policeman in full uniform, standing behind and embracing Robyn, a young woman in a tank top and short-shorts? How old is she? What is that look on her face? Is it apprehension, or is that just the way her face is? Why is this image even less comfortable to look at than the one of Lee and Lindsey, the nudists on p. 72 who stand in a similar pose to Nathan and Robyn, and between whom there's an even greater age gap? There is also a cumulative effect of seeing the several pictures here in which people of different races touch or hold each other. The racial division in the United States remains stark, with most of the population practicing some form of "separate but equal." It is impossible to look at Renaldi's photographs without being a little sad at how rare it is to see, on the streets, in the diners, in the parks and public places of this country, some version of the invented narratives illustrated on pp. 33, 35, 39 and 43. Their photographic

fiction is a reminder of how shoddy reality can be in comparison to the imagination.

But *Touching Strangers*, even when it alerts us to society's hypocrisies, also does something more basic and more subtle: it brings us a reconsideration of the mystery of touch. Of the five traditional senses, touch is the only one that is reflexive: one can look without being seen, and hear without being heard, but to touch is to be touched. It is a sense that goes both ways: the sensitivity of one's skin responds to and is responded to by the sensitivity of other people's skin. This perhaps is why so many of these pictures project an air of gentleness, compassion, friendship, or care. There is something irreducible about the effect of touching another human being, or witnessing such contact. We see the results on the faces of the subjects of these photographs. The images play with the illusion of straightforwardness and testimony, and at the same time find their ways to precisely those values. Between the moment when a stranger is approached on the street and the moment when a print is made, some transformative magic takes place.

Renaldi's work is patient, done with a large-format camera, slow in the making, dependent on the cooperation of strangers. And yet, because these are strangers out in public, the element of unpredictability is ever-present. In the novel *Double Negative*, by the South African novelist Ivan Vladislavić, one of the protagonists observes that, "A photograph is an odd little memorial that owes a lot to chance and intuition." Renaldi has shepherded chance and intuition into something both luminous and unreassuring. His photographs, once seen, are hard to put out of mind. The stories they evoke have a depth echoing beyond the brief encounters that occasioned them. A photograph is nothing but surface, but there are ineffable truths in the way things look; how things seem can be more startling than how they are. As Oscar Wilde wrote, "It is only shallow people who do not judge by appearances. The true mystery of the world is the visible, not the invisible."

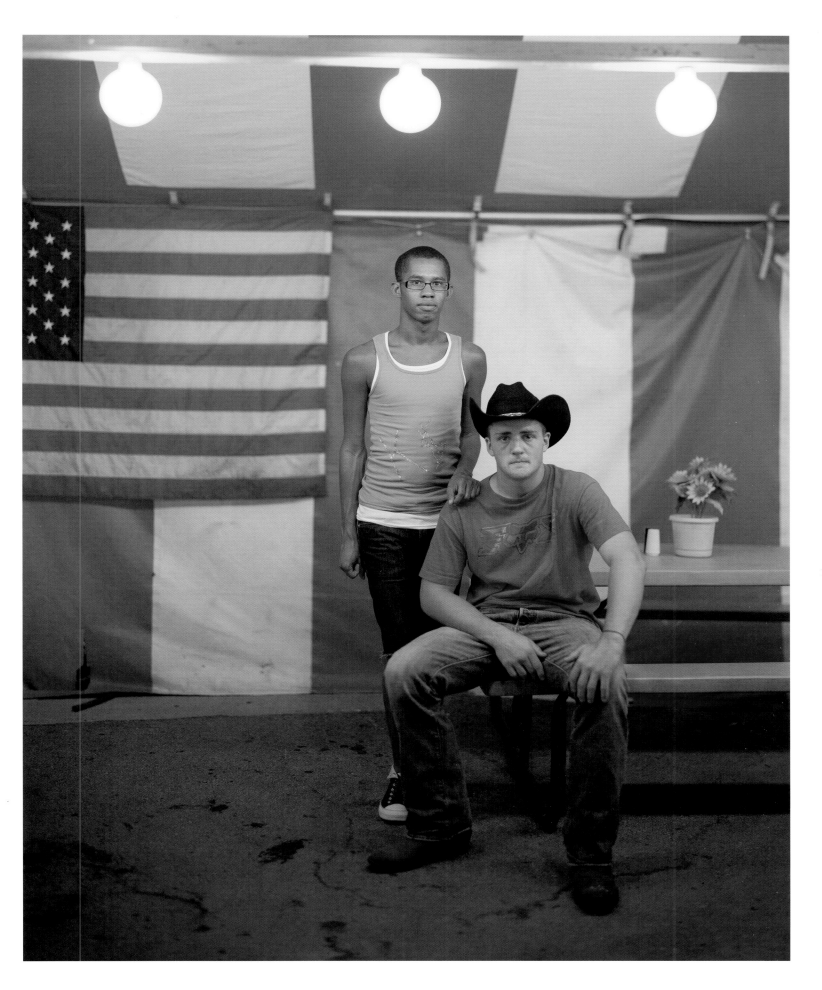

Jeromy and Matthew COLUMBUS, OHIO, 2011

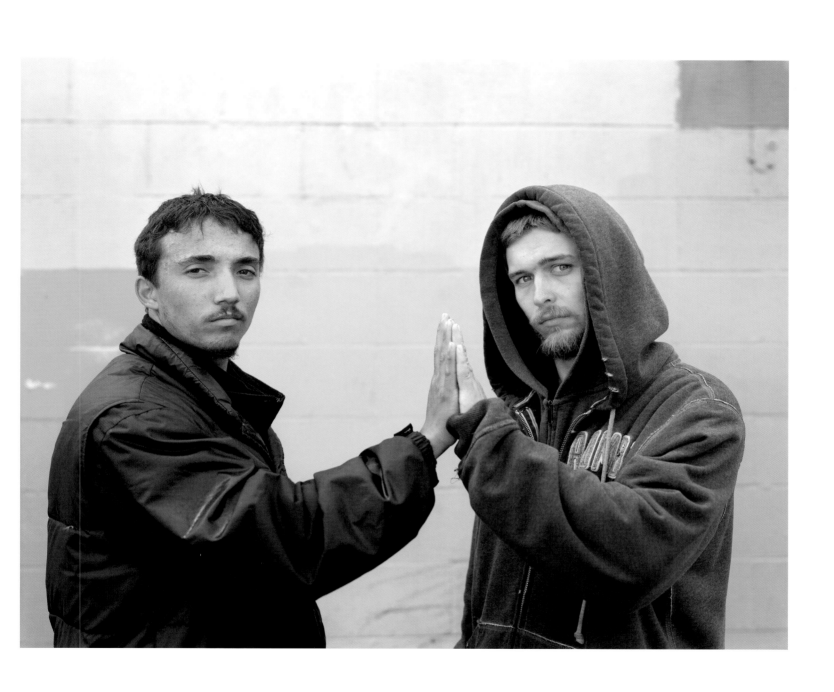

Vincent and Charles   LOS ANGELES, CALIFORNIA, 2012

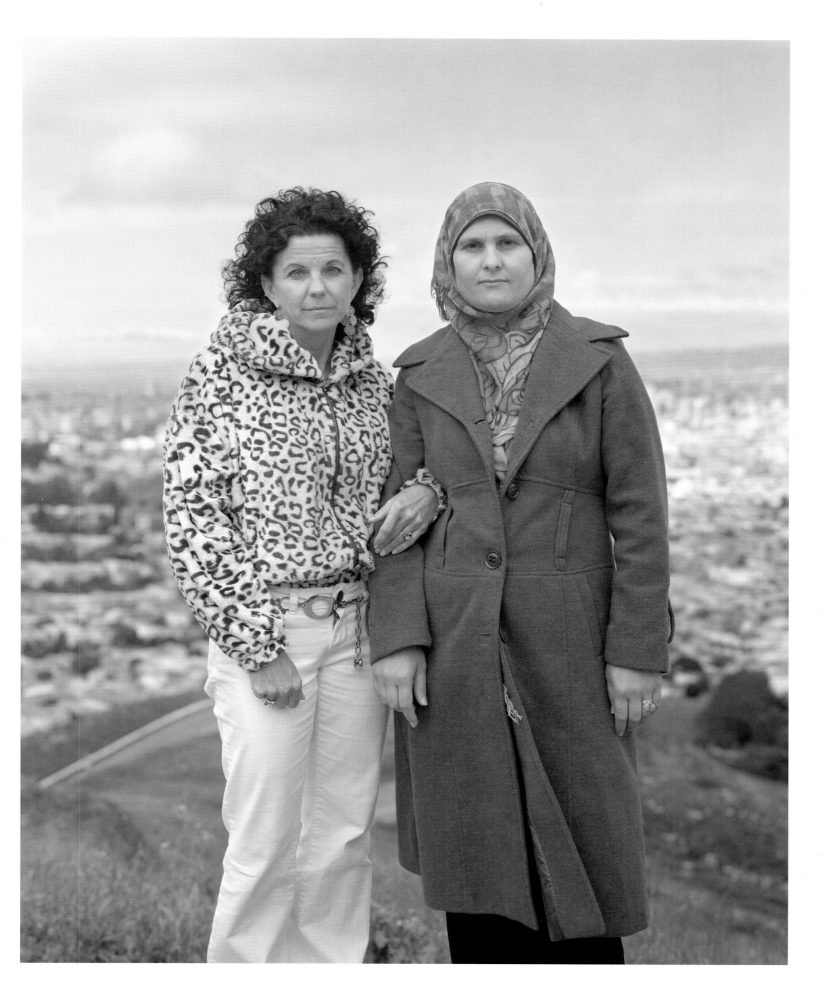

Annalee and Rayqa   SAN FRANCISCO, CALIFORNIA, 2012

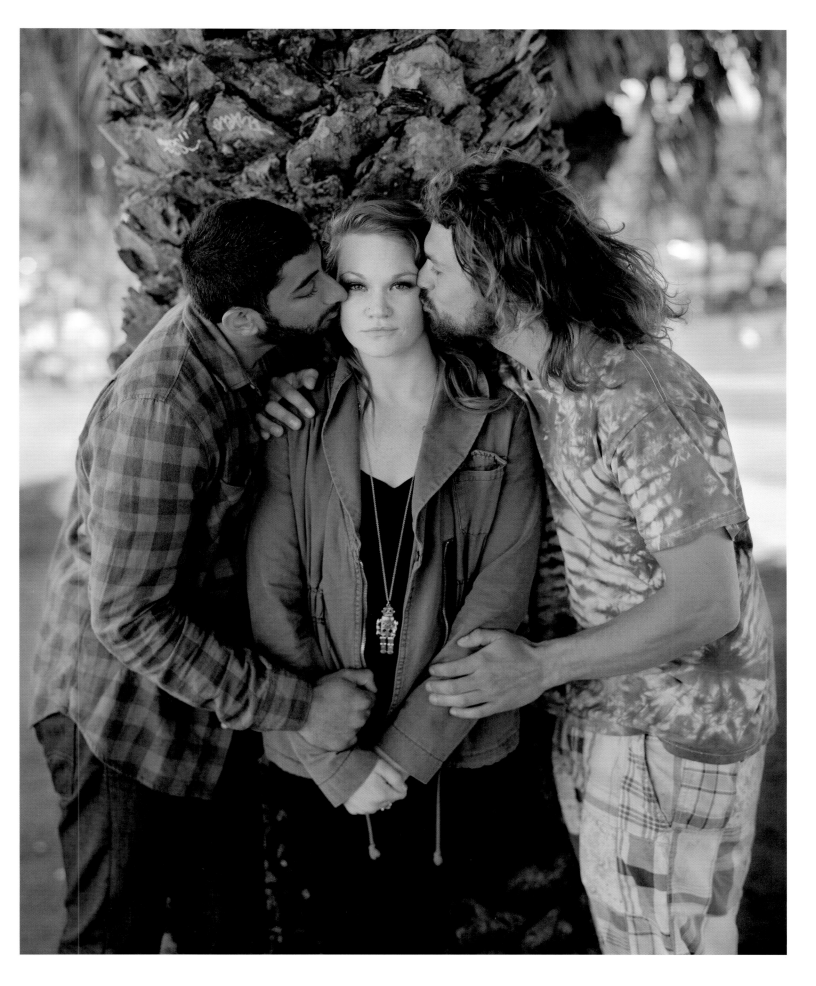

Tom, Alaina, and Charlie  SAN FRANCISCO, CALIFORNIA, 2012

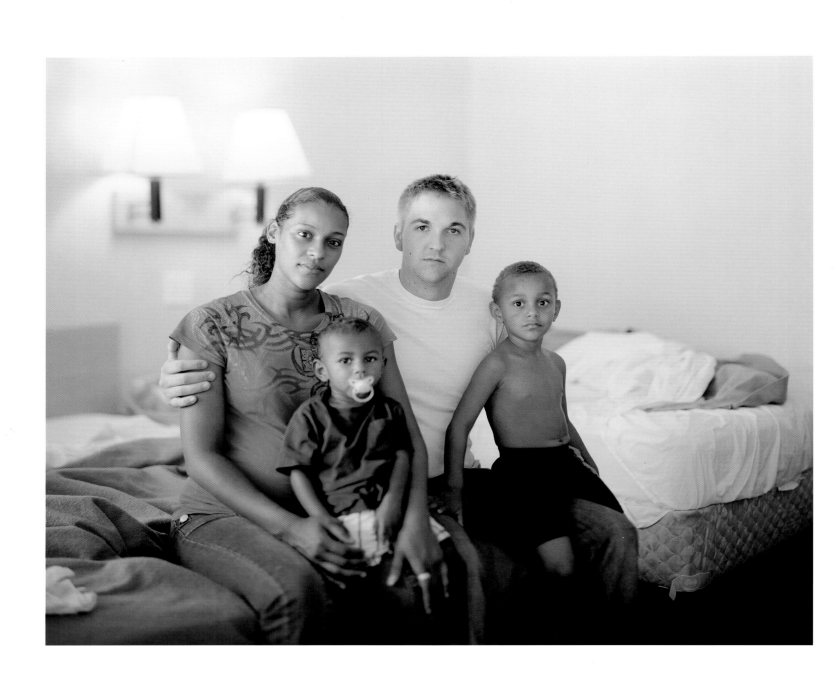

Sonia, Zach, Raekwon, and Antonio  TAMPA, FLORIDA, 2011

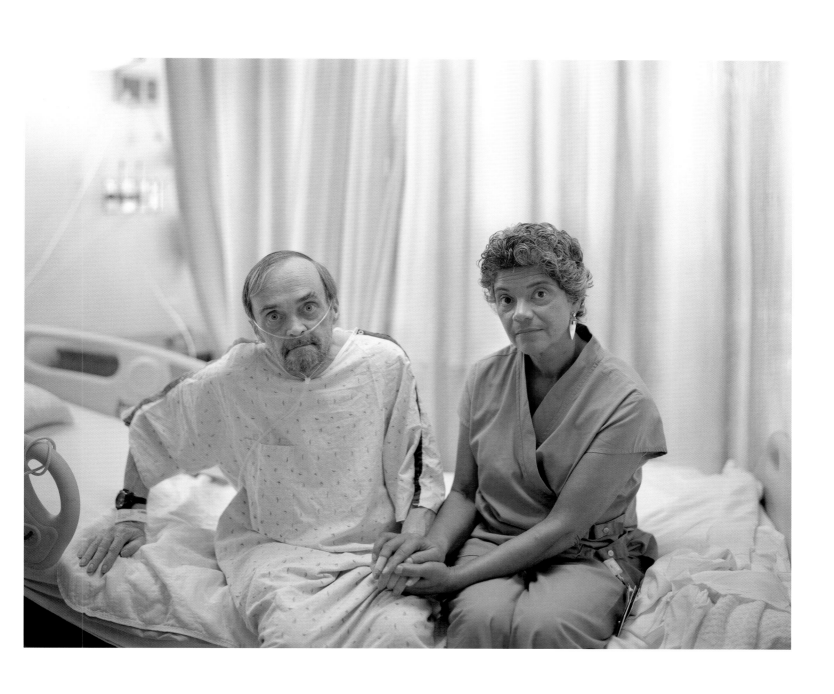

Joseph and Deborah   PORT JERVIS, NEW YORK, 2011

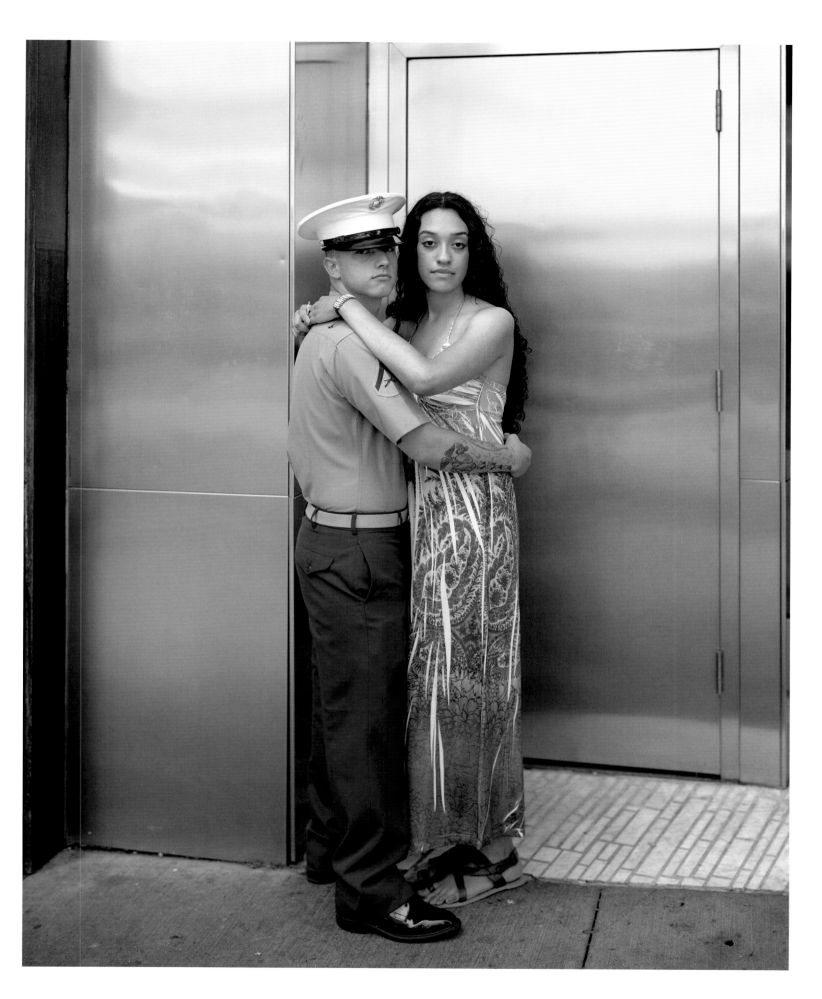

Michael and Kimberly   NEW YORK, NEW YORK, 2011

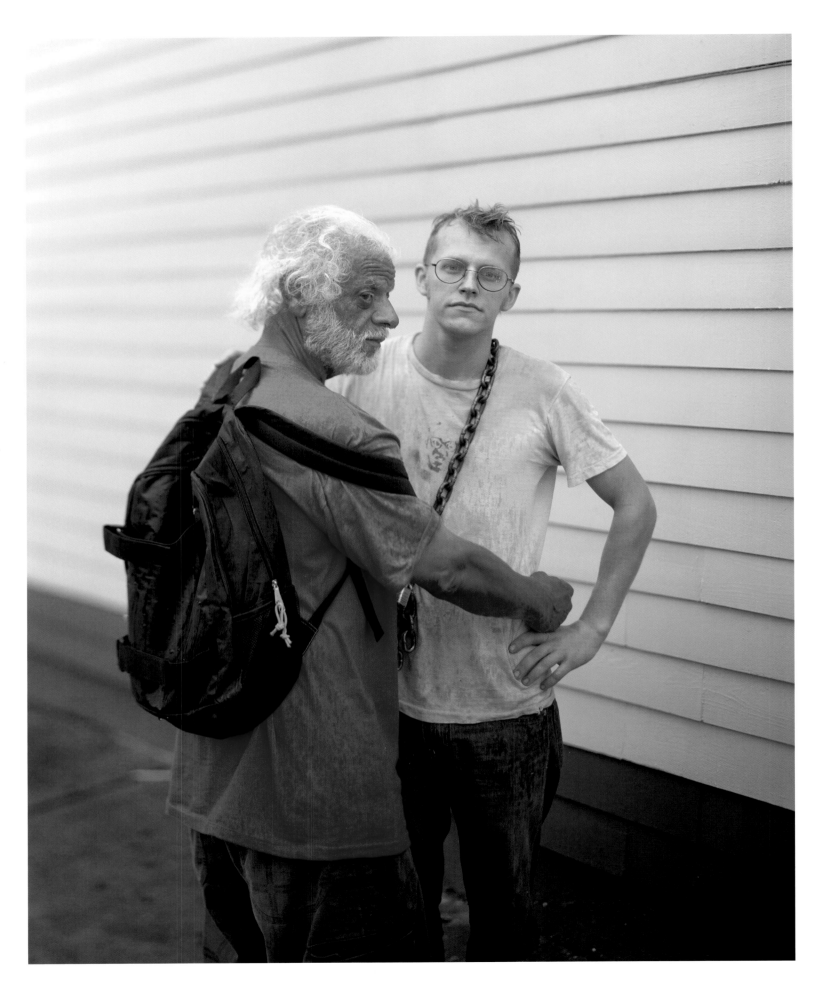

Hewitt and Ryan   NEW ORLEANS, LOUISIANA, 2012

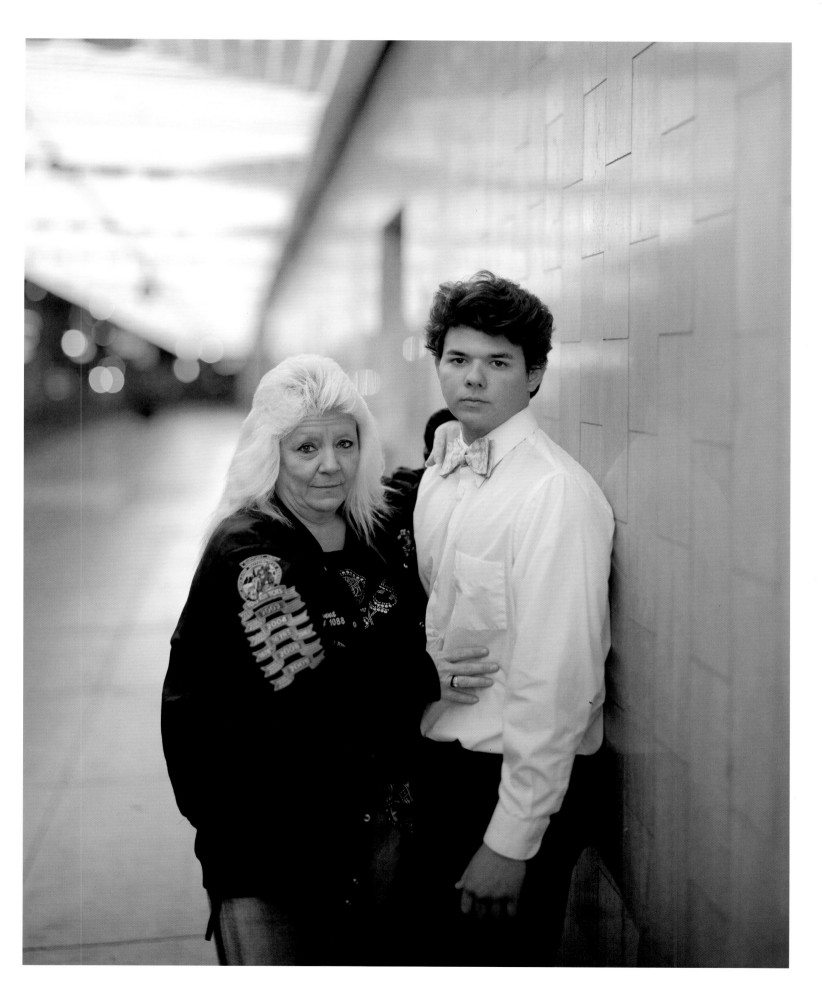

Donna and Eben   LAS VEGAS, NEVADA, 2012

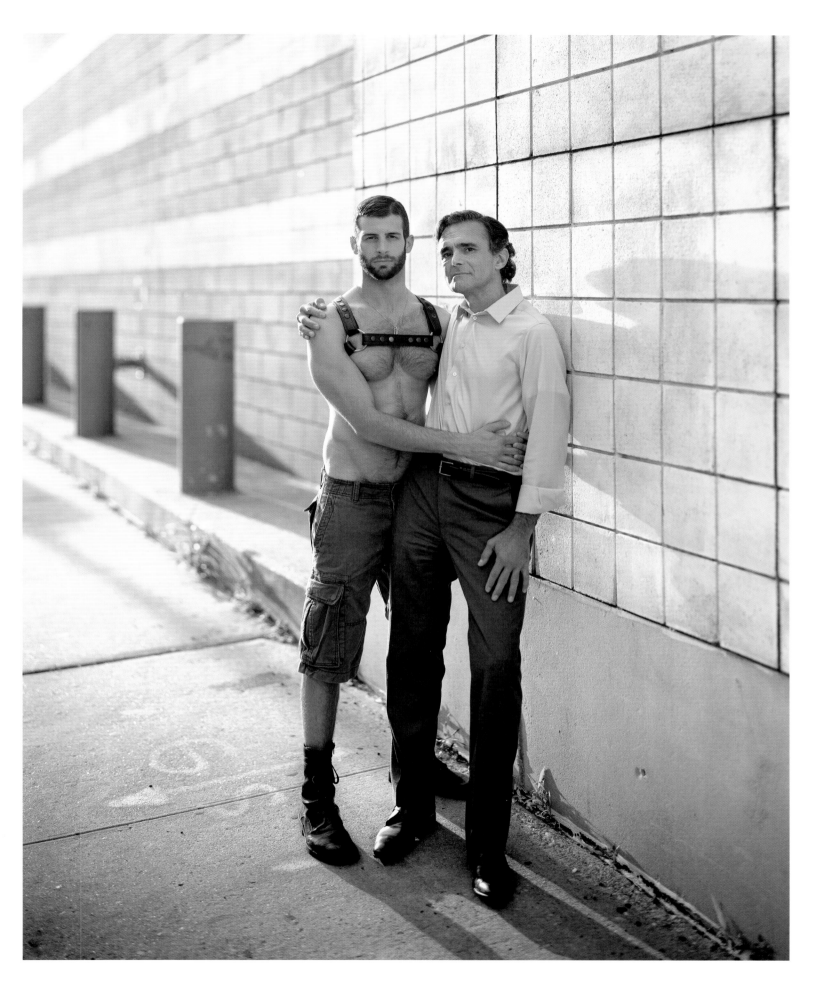

David and Claudio  NEW YORK, NEW YORK, 2011

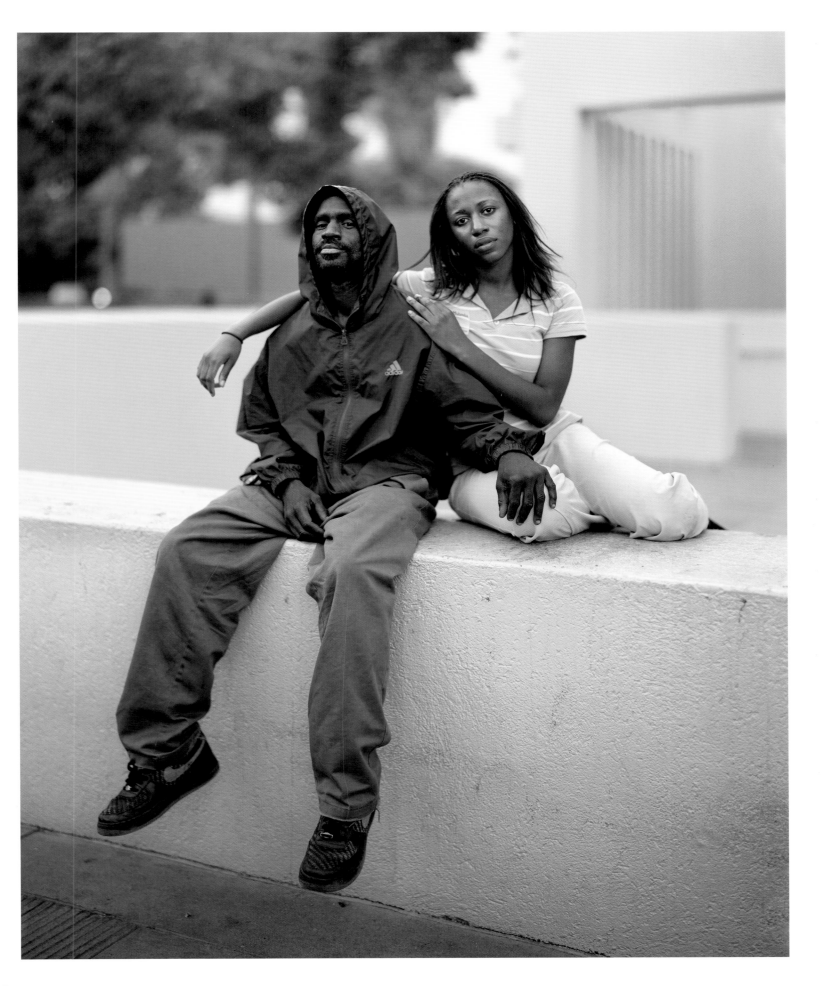

Reginald and Nicole   LOS ANGELES, CALIFORNIA, 2007

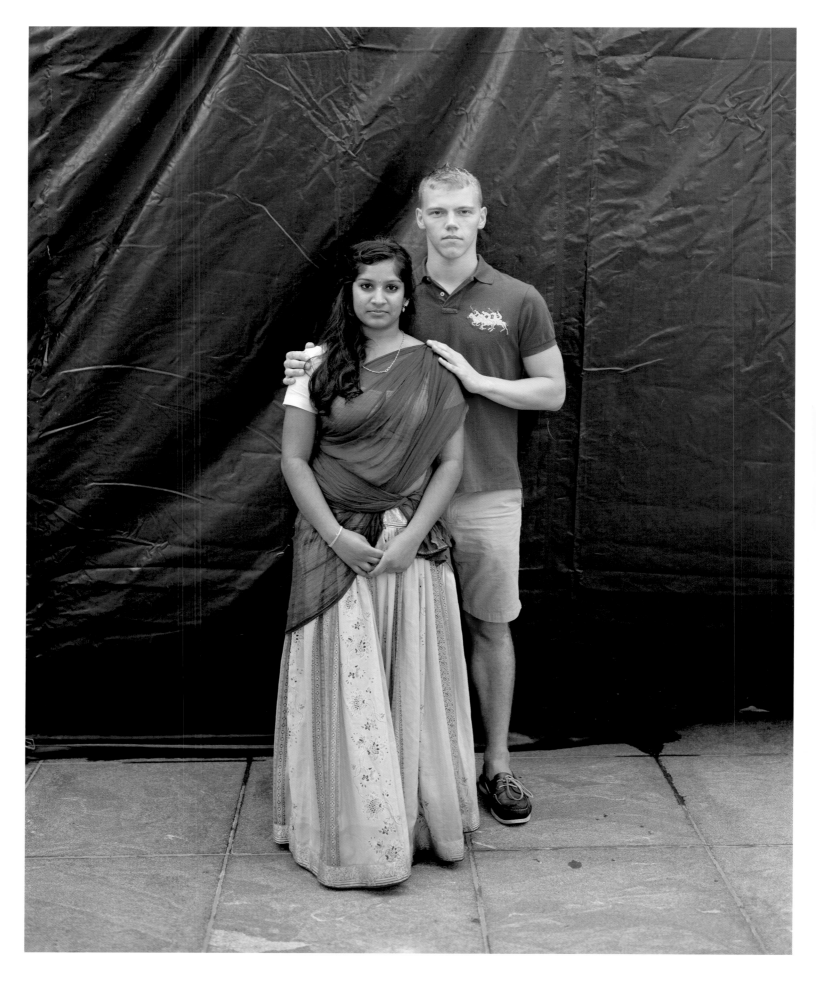

Radhika and Lucas   NEW YORK, NEW YORK, 2011

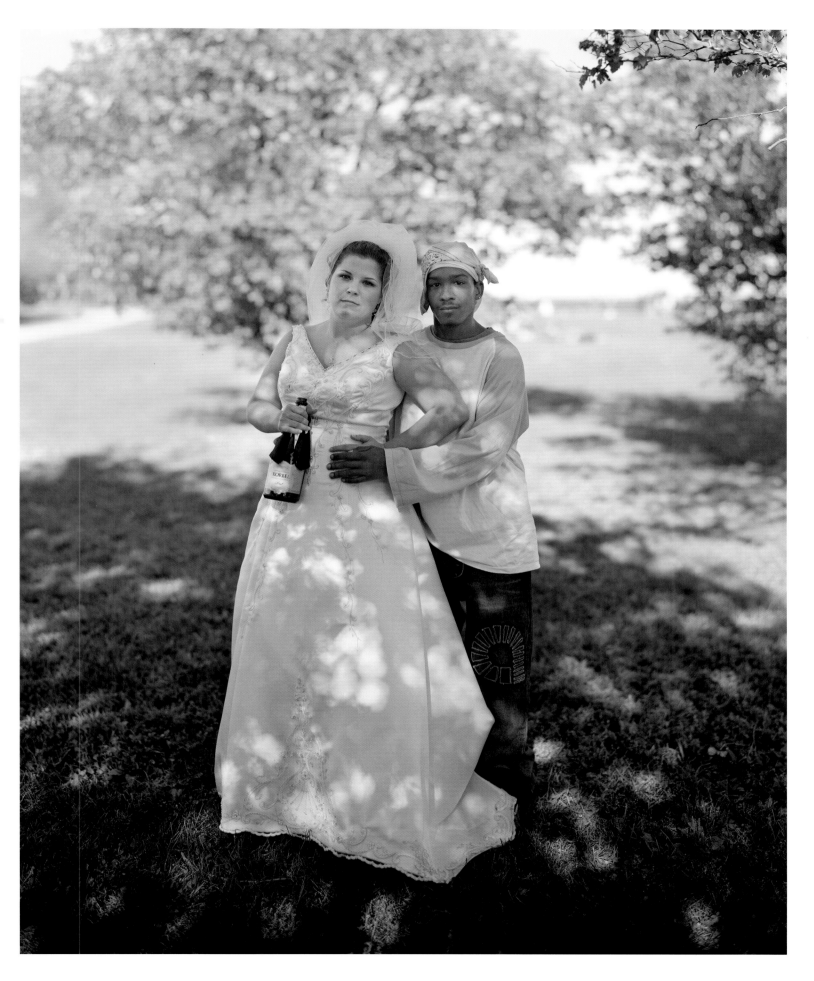

Julie and Xavier  CHICAGO, ILLINOIS, 2007

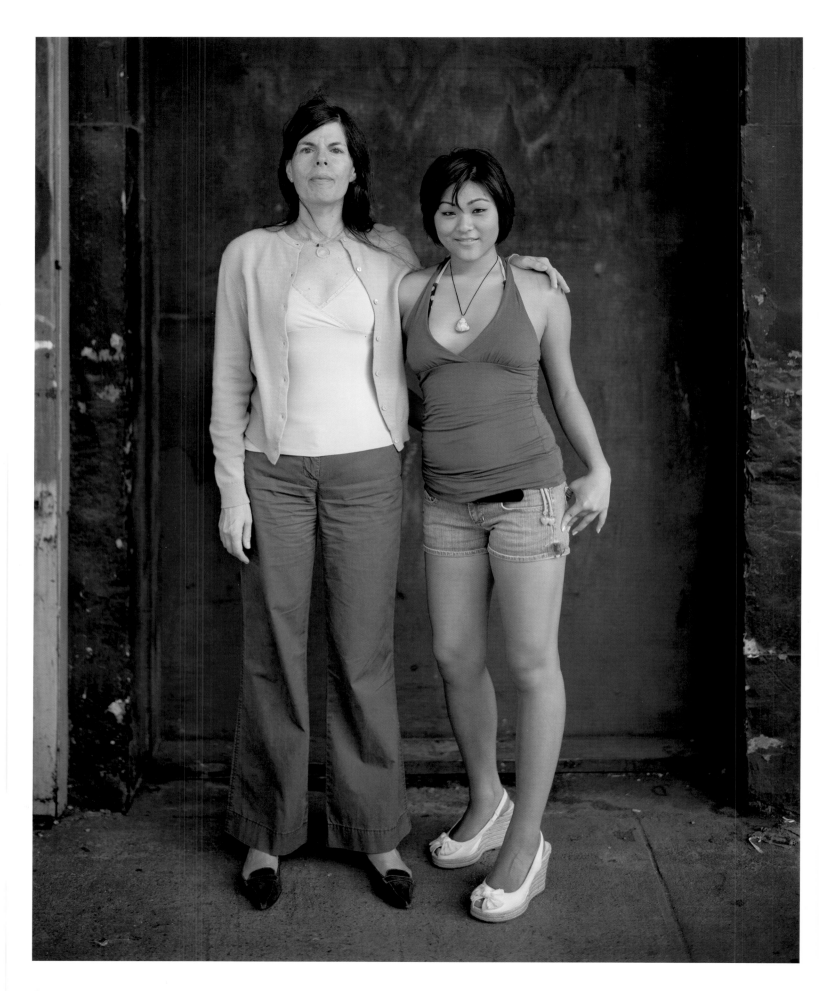

Ilene and Loria  NEW YORK, NEW YORK, 2007

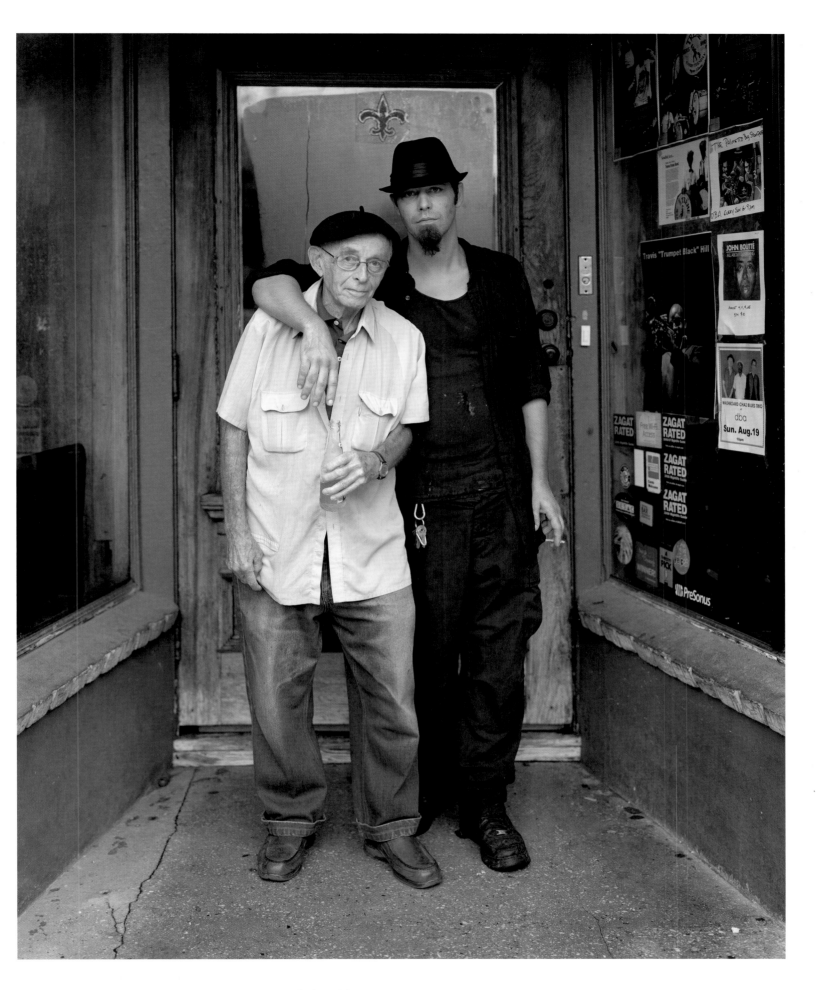

Jack and Lance   NEW ORLEANS, LOUISIANA, 2012

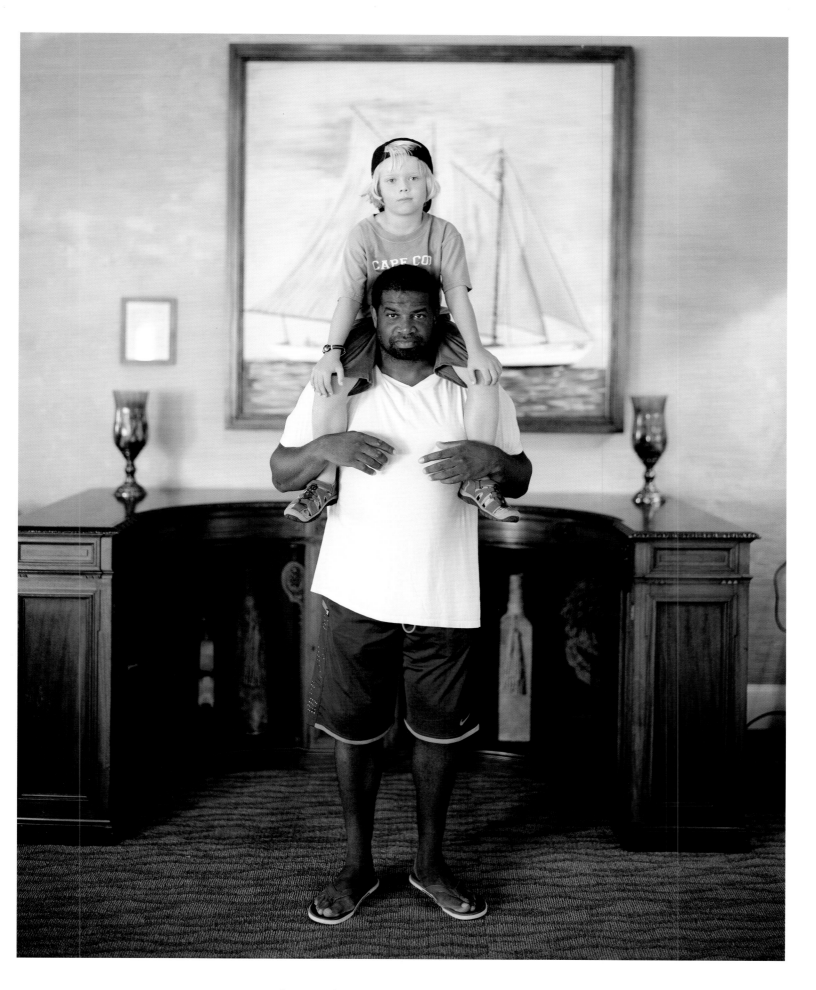

Craig and Gabe  PROVINCETOWN, MASSACHUSETTS, 2011

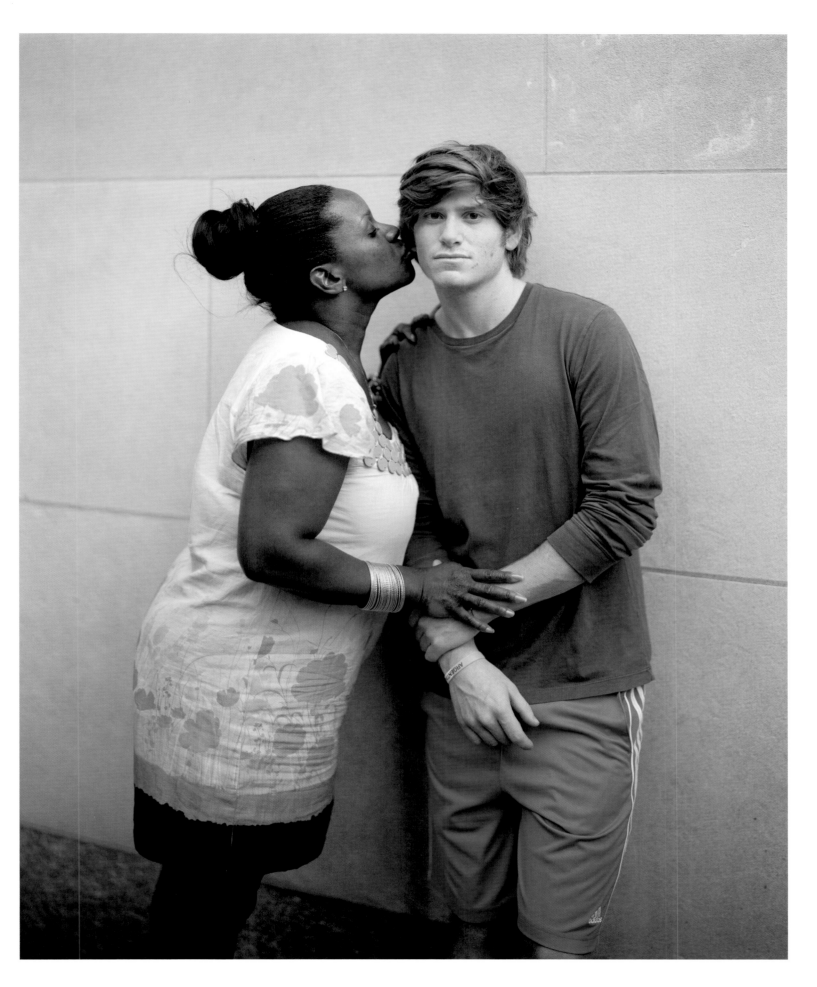

Kiya and Simon NEW YORK, NEW YORK, 2012

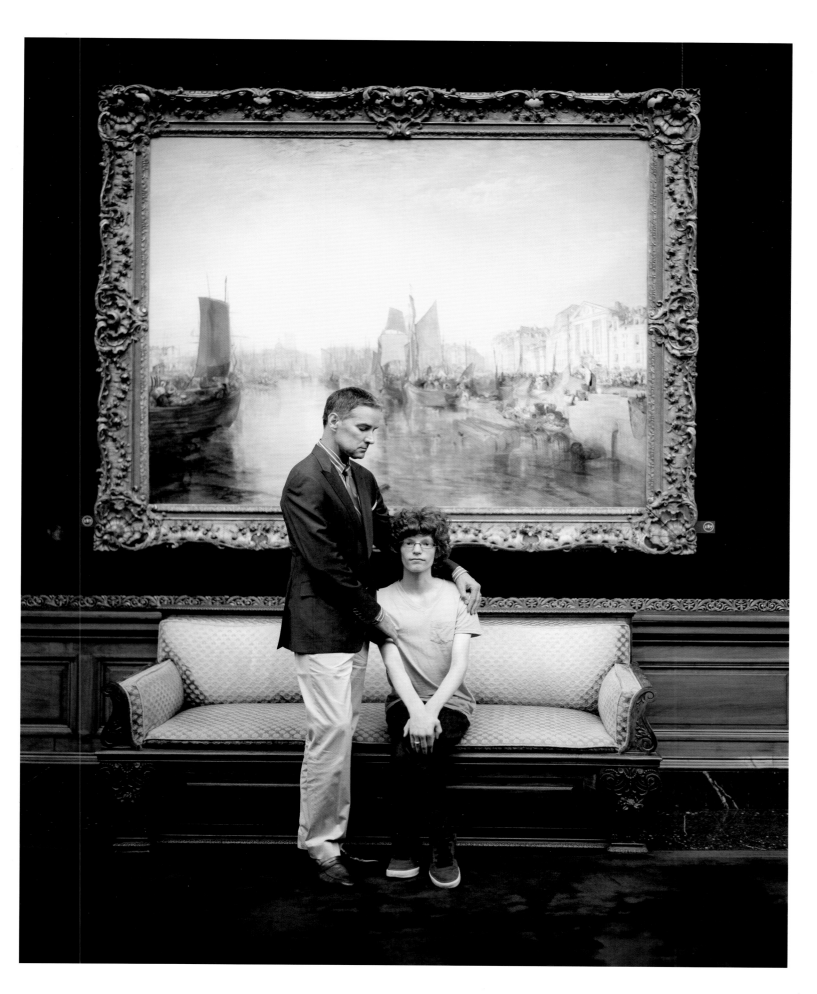

Jared and Seth   NEW YORK, NEW YORK, 2013

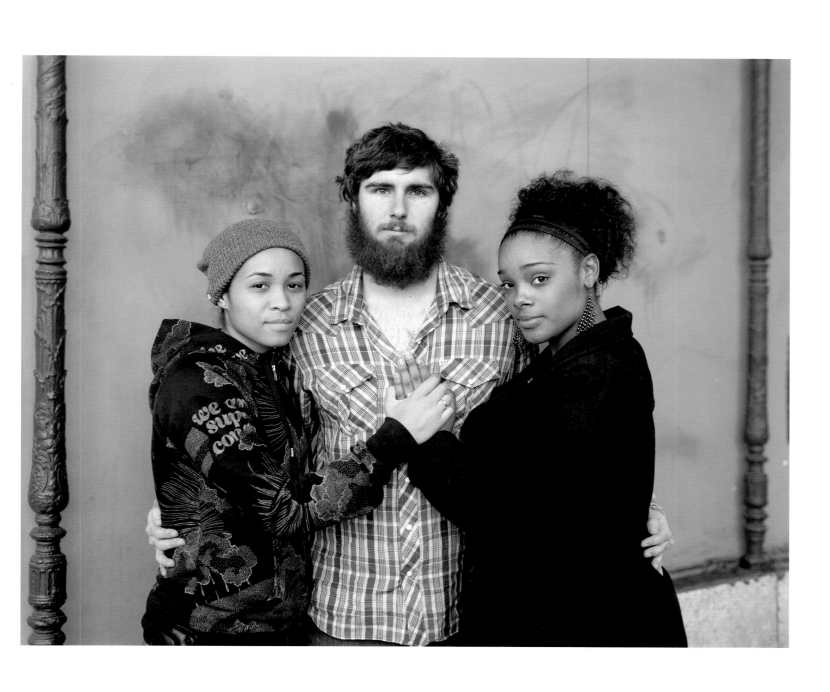

Tari, Shawn, and Summer  LOS ANGELES, CALIFORNIA, 2012

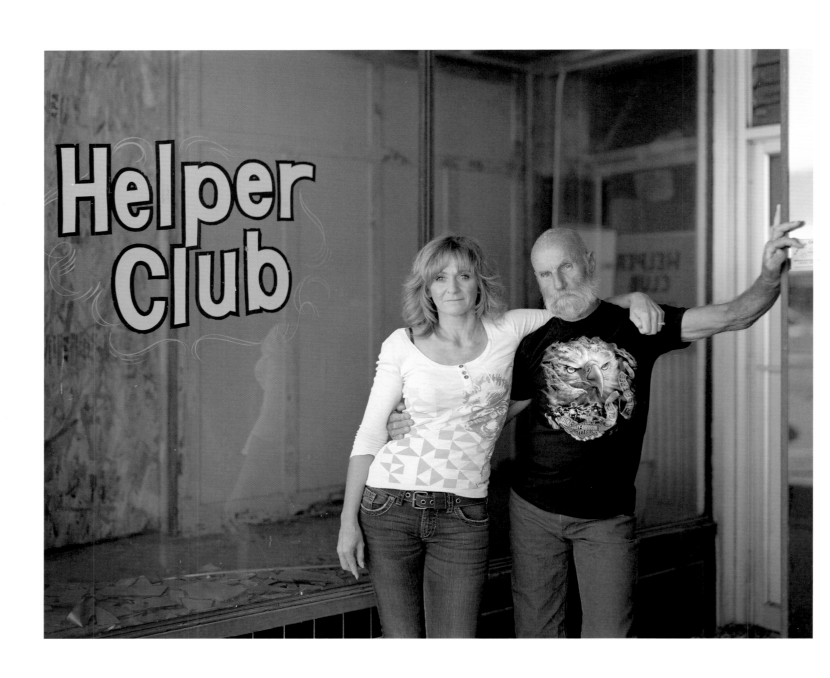

Jalynn and Dennis HELPER, UTAH, 2011

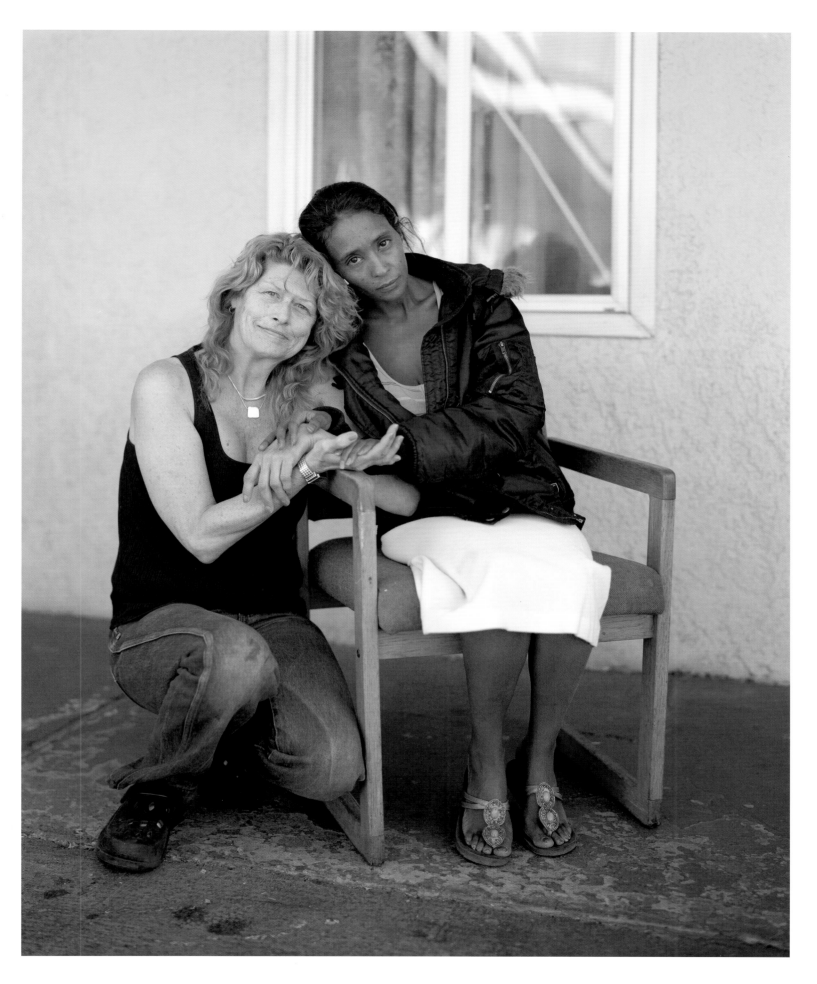

Carey and Maaza   LAS VEGAS, NEVADA, 2012

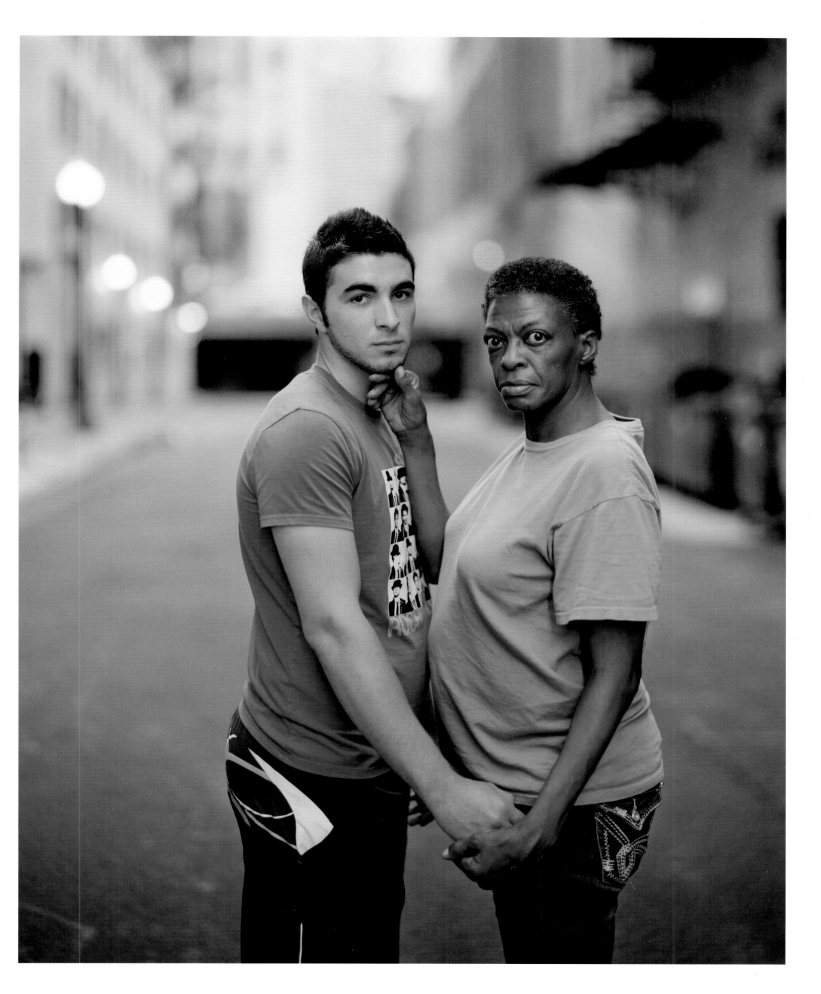

Andrea and Lillie  CHICAGO, ILLINOIS, 2013

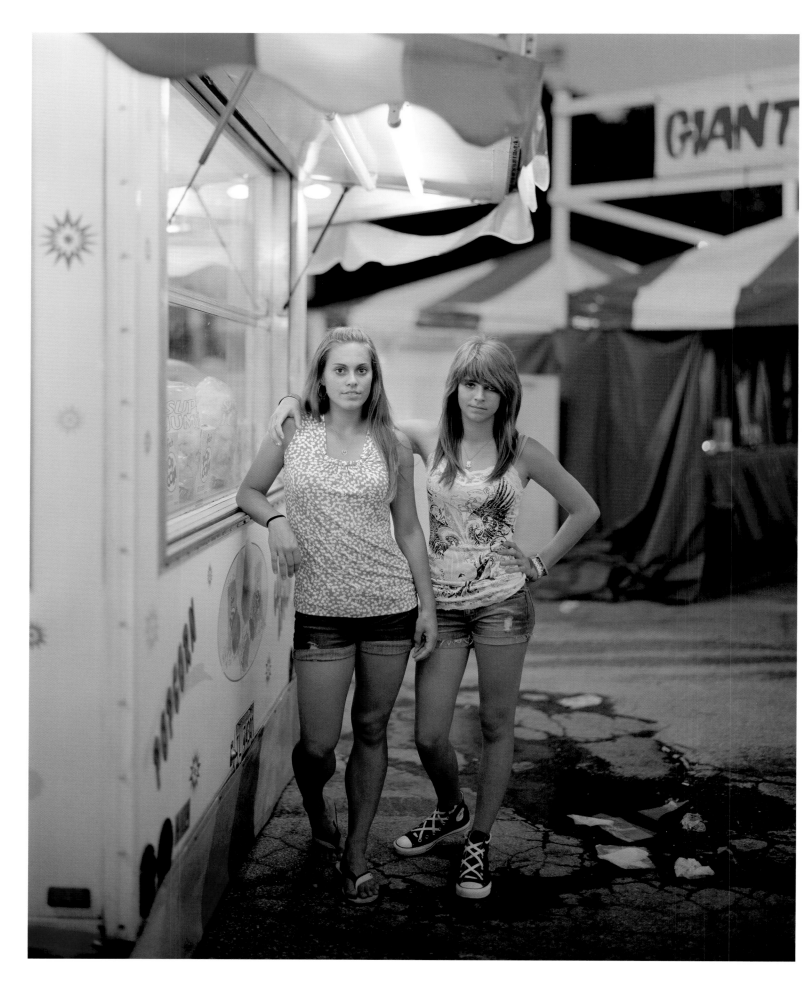

Jacqueline and Halle COLUMBUS, OHIO, 2011

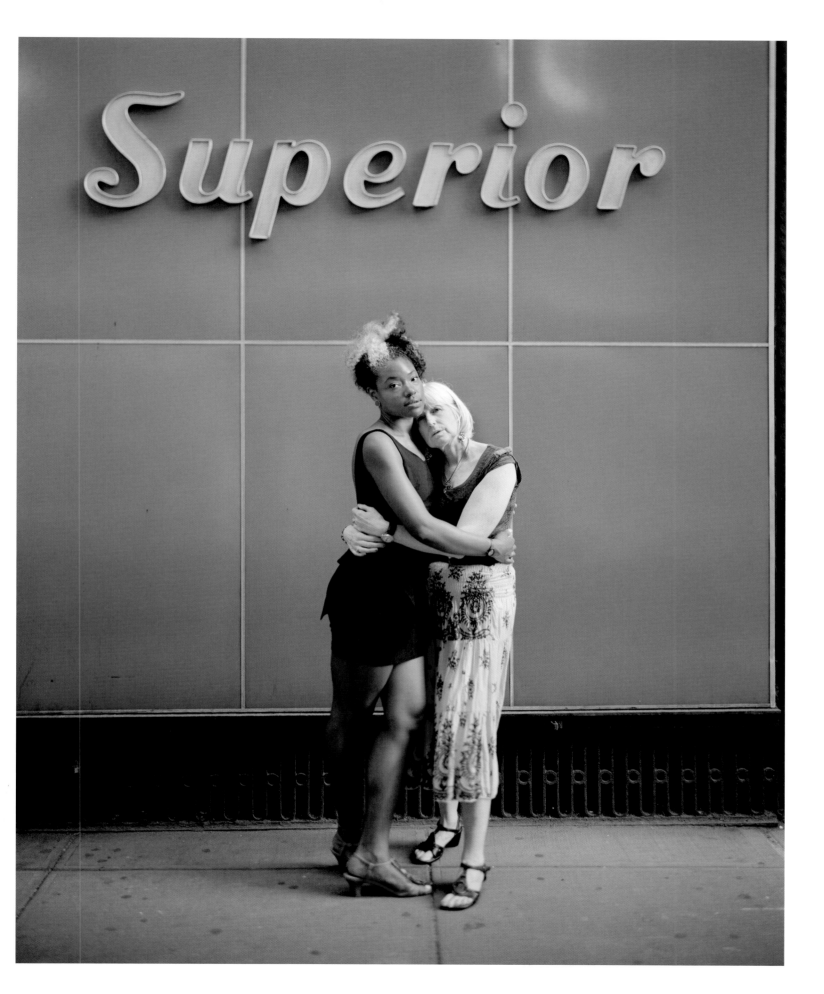

Elaine and Arly   NEW YORK, NEW YORK, 2012

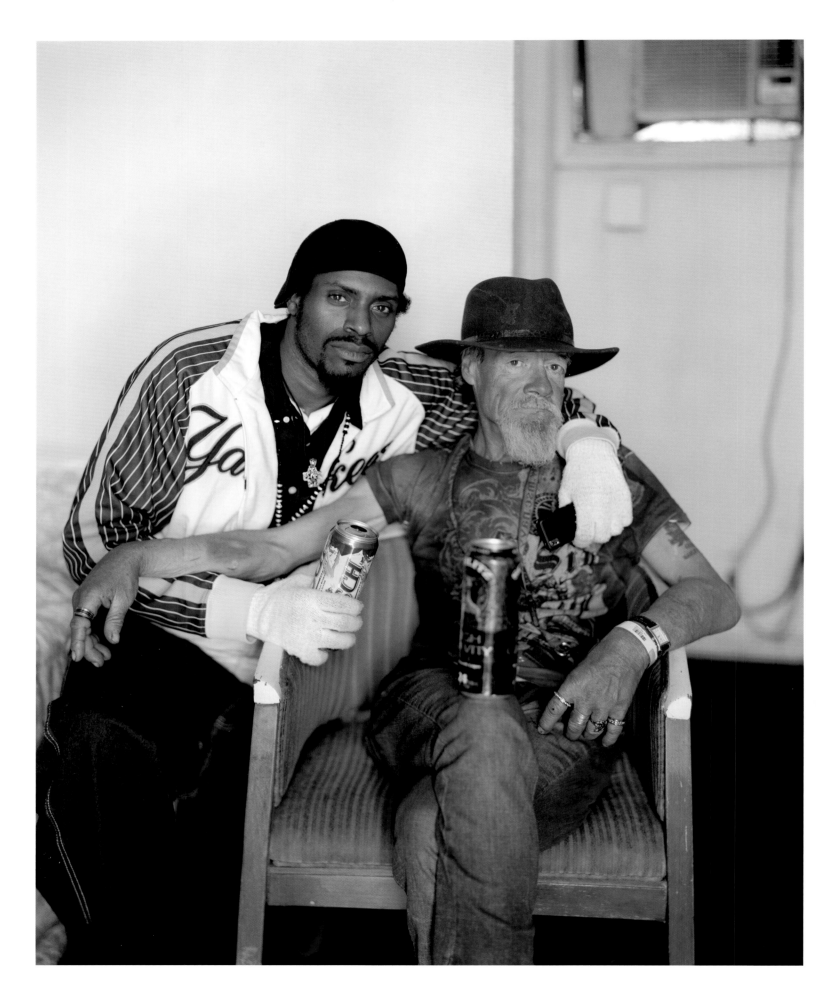

Perry and Mark  LAS VEGAS, NEVADA, 2012

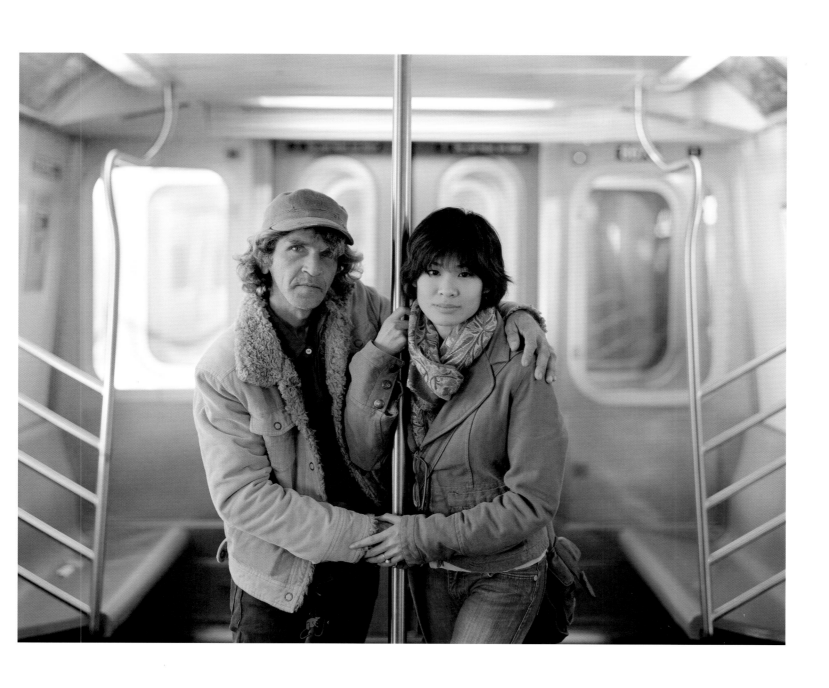

Alfredo and Jessica   QUEENS, NEW YORK, 2011

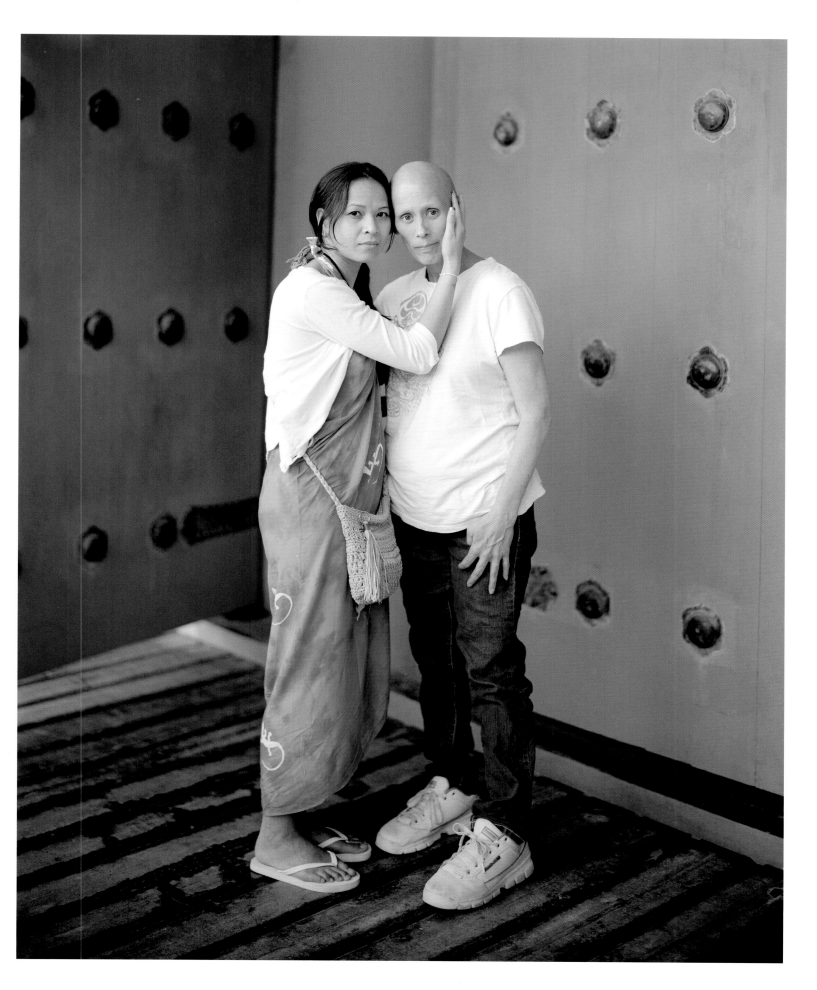

Soukhet and Dawn   KANEOHE, HAWAII, 2012

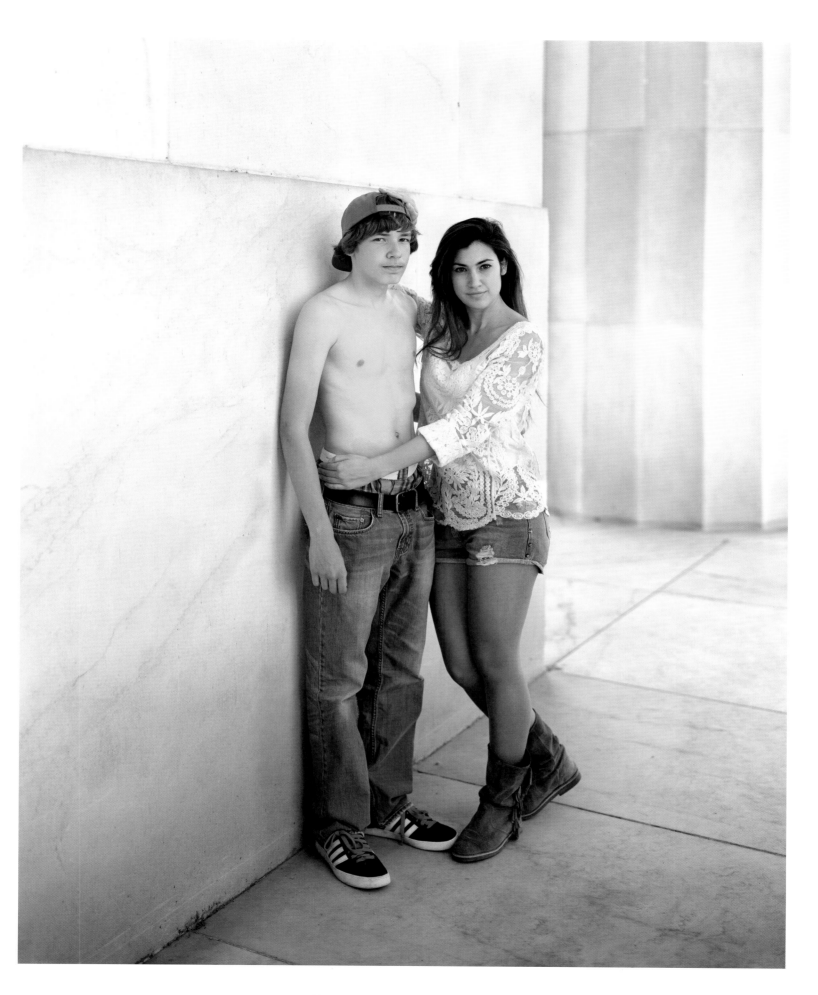

Alex and Maria WASHINGTON, D.C., 2013

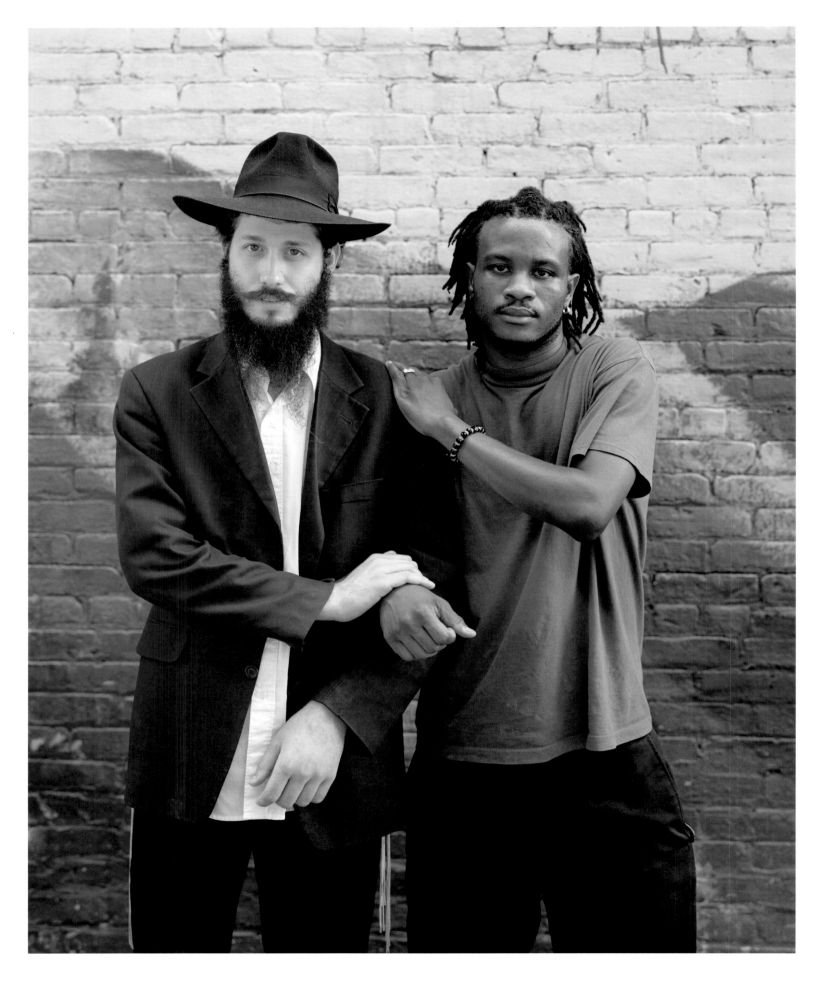

Shalom and Jeff  BROOKLYN, NEW YORK, 2013

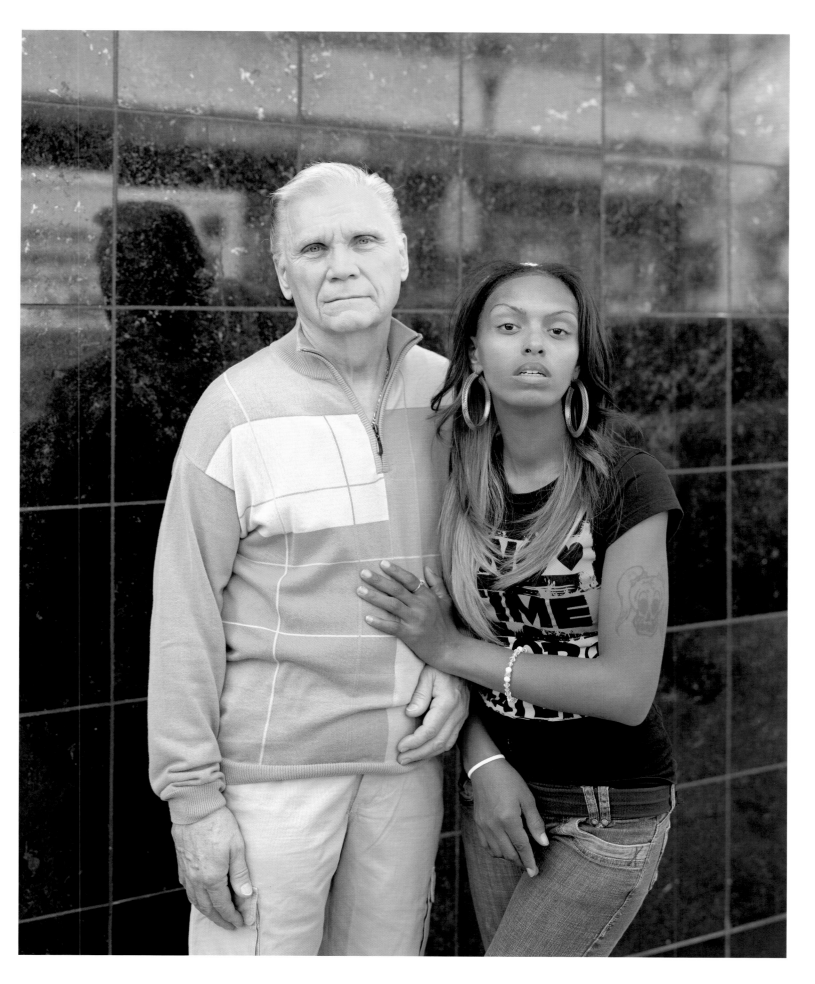

Stanley and Carla   PHILADELPHIA, PENNSYLVANIA, 2013

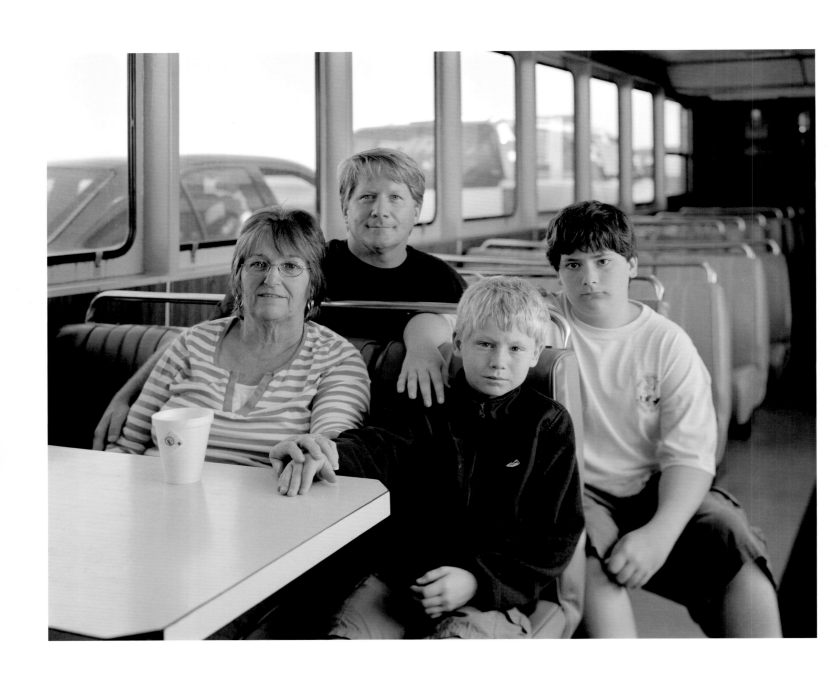

Guy, Jamie, Tre, and Nancy   OCRACOKE ISLAND FERRY, NORTH CAROLINA, 2011

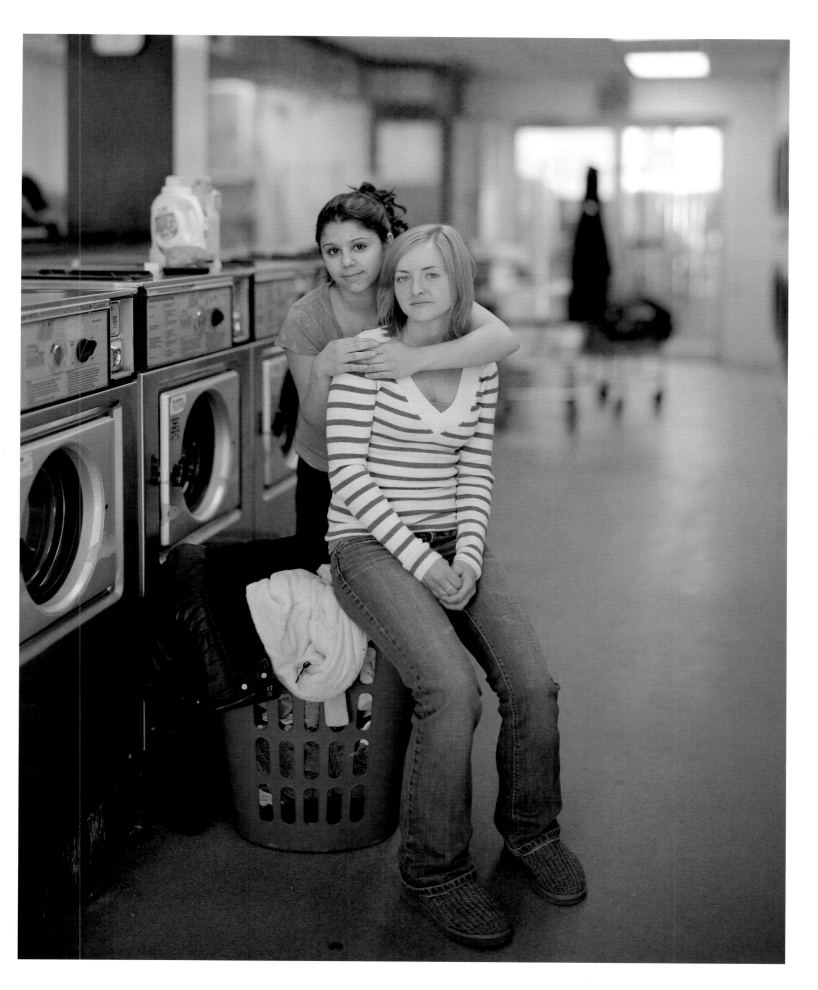

Sondra and Erin   MILFORD, PENNSYLVANIA, 2011

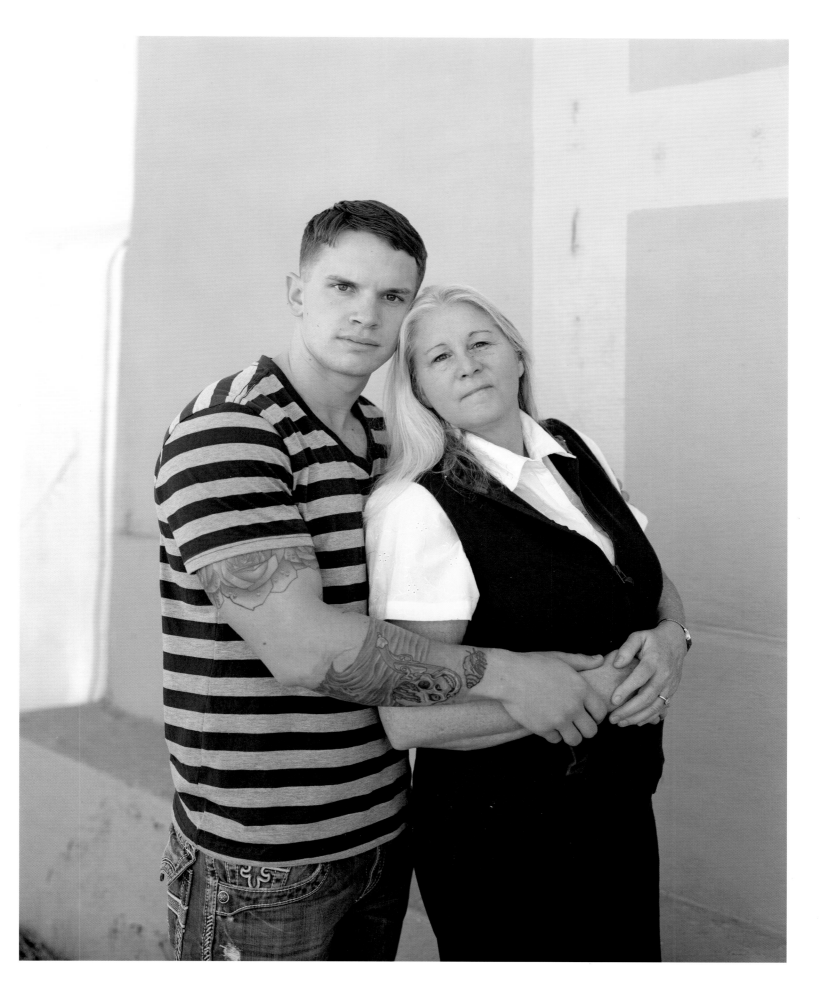

Trevor and Heidi  TWENTYNINE PALMS, CALIFORNIA, 2012

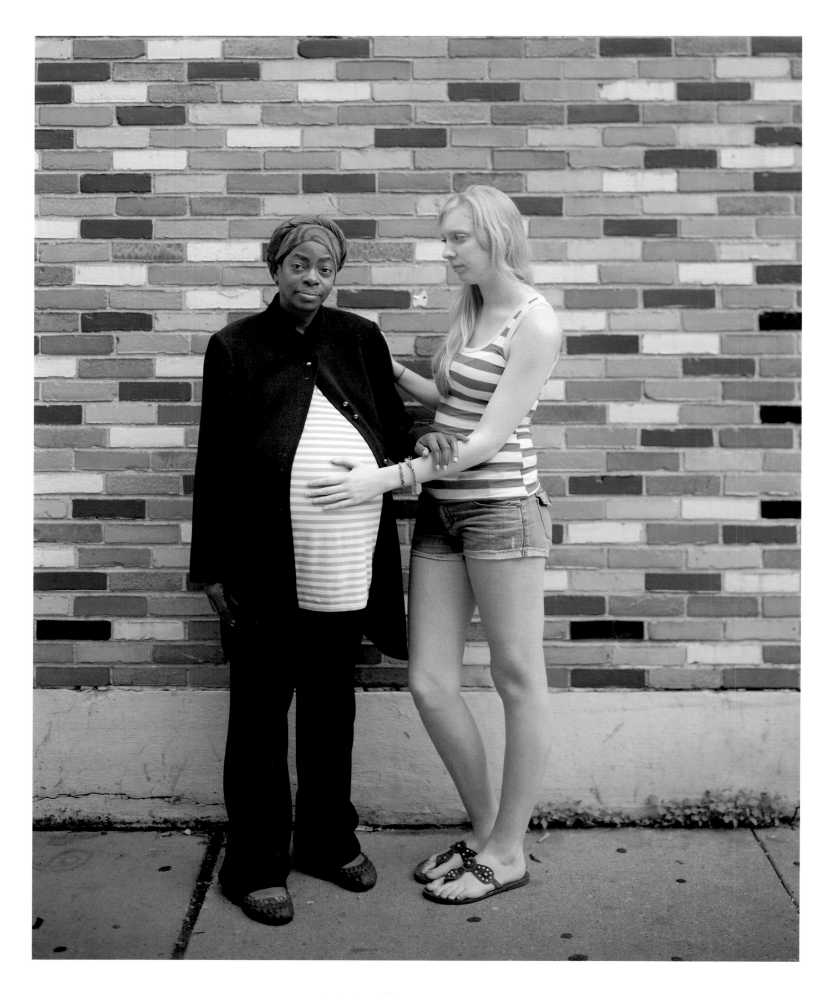

Aminah and Erica  CHICAGO, ILLINOIS, 2013

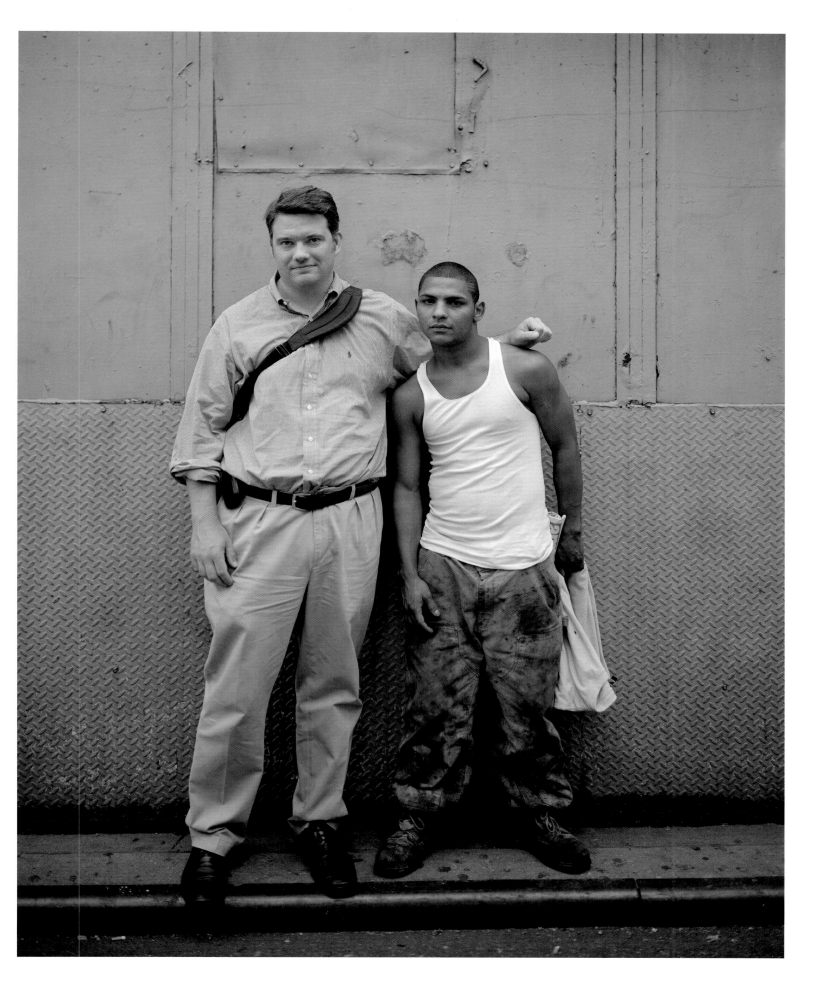

Alex and Carlos   NEW YORK, NEW YORK, 2007

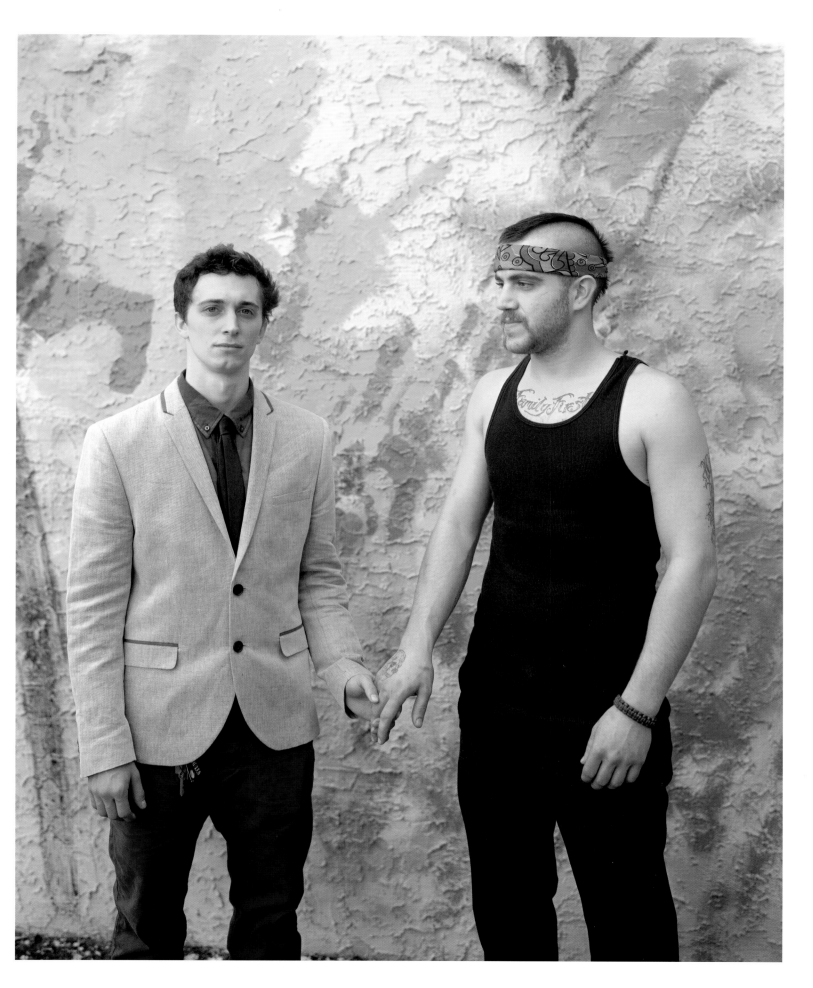

Nicholas and Caleb PHILADELPHIA, PENNSYLVANIA, 2013

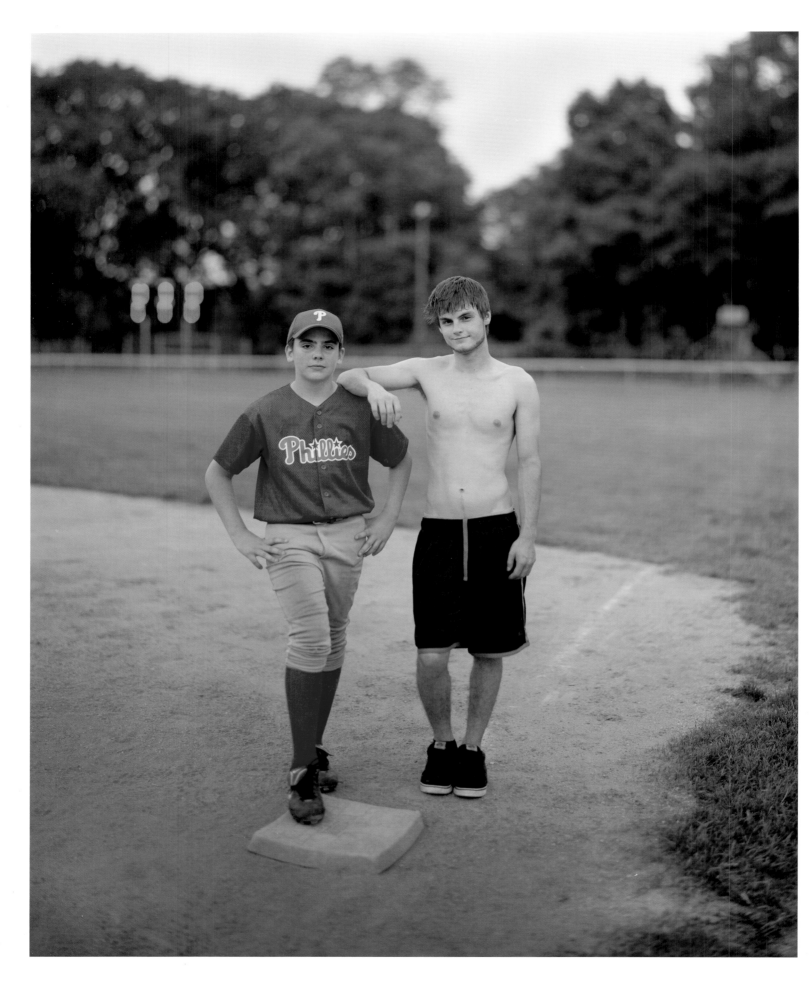

Cal and Joshua  MILFORD, PENNSYLVANIA, 2011

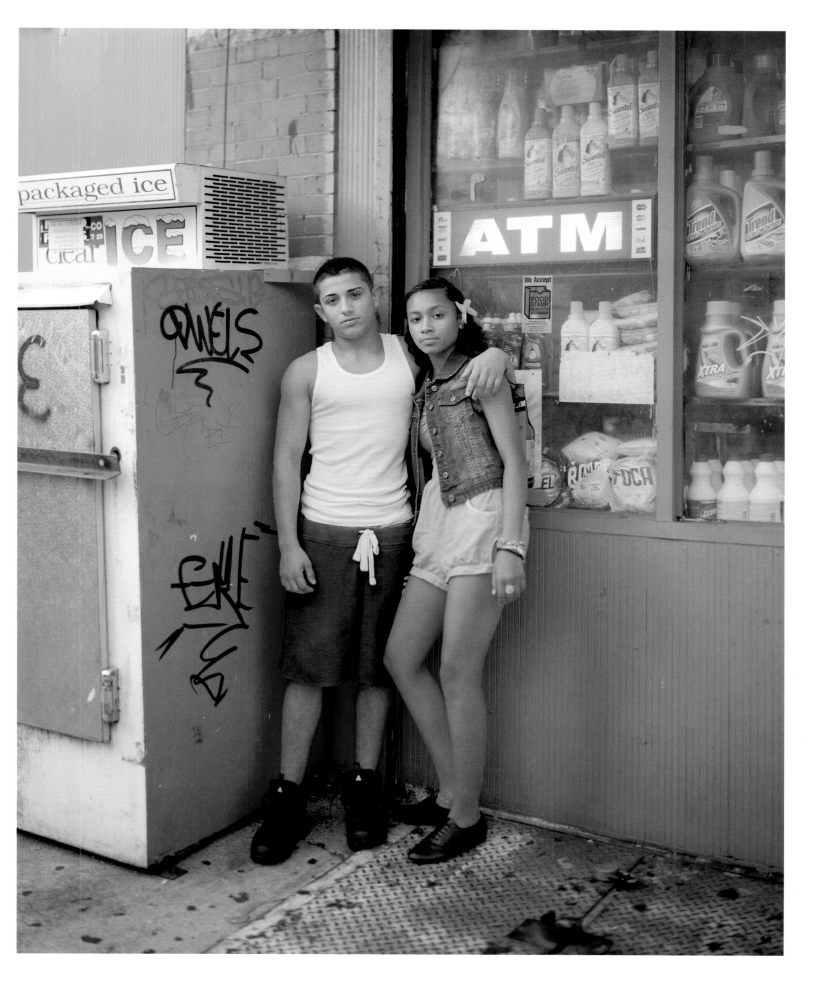

Atiljan and Tiffany   BRONX, NEW YORK, 2011

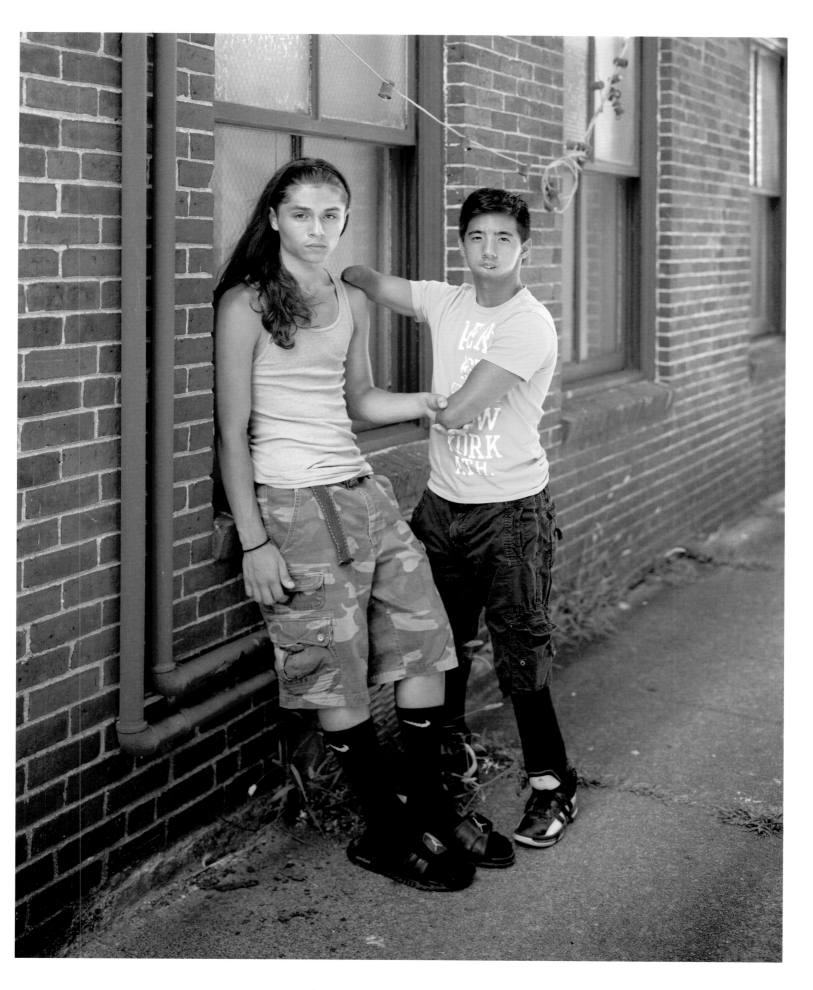

Junior and Petey NEW BEDFORD, MASSACHUSETTS, 2012

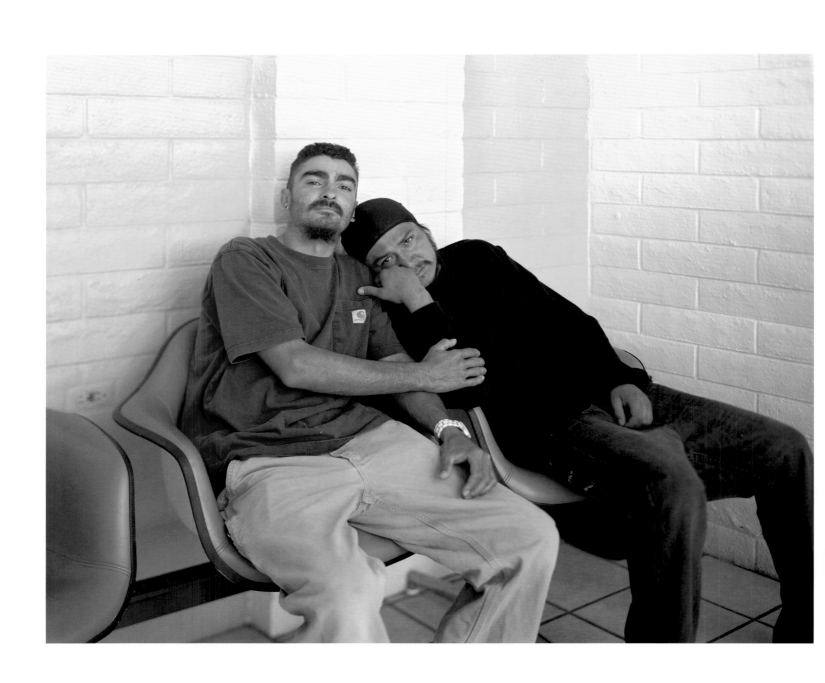

Johnathan and Trae  ALBUQUERQUE, NEW MEXICO, 2013

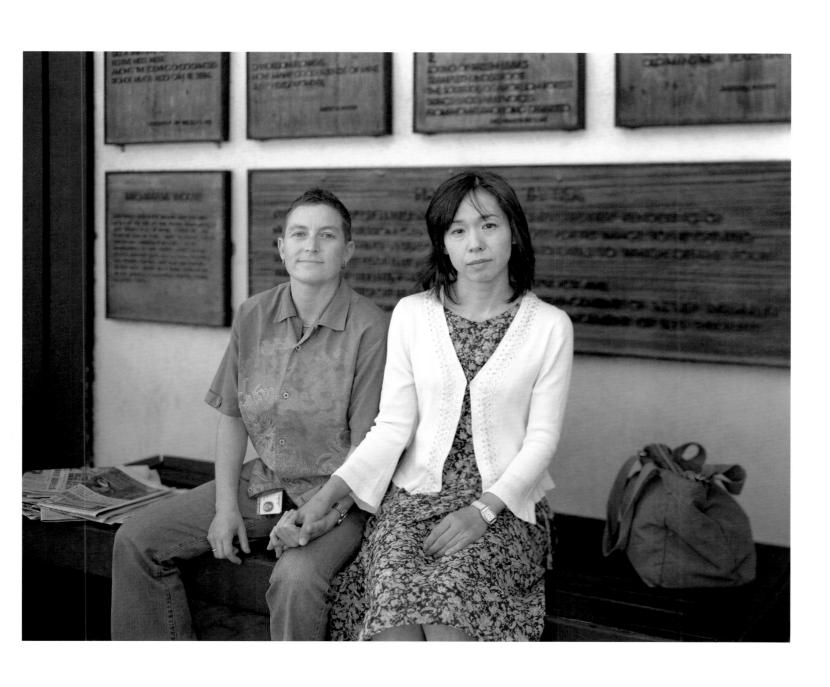

Kim and Yoshie  LOS ANGELES, CALIFORNIA, 2007

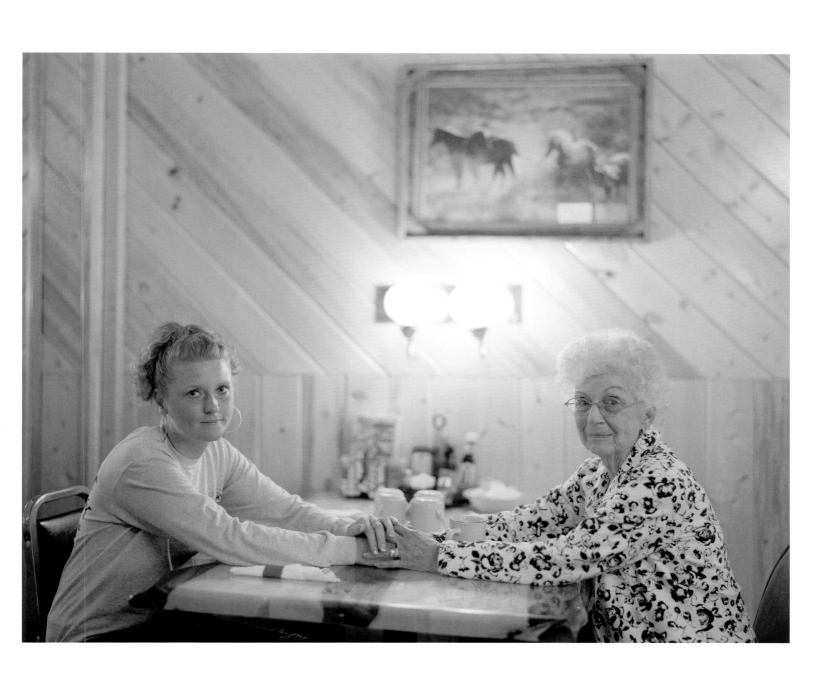

Donna and Donna CRAIG, COLORADO, 2011

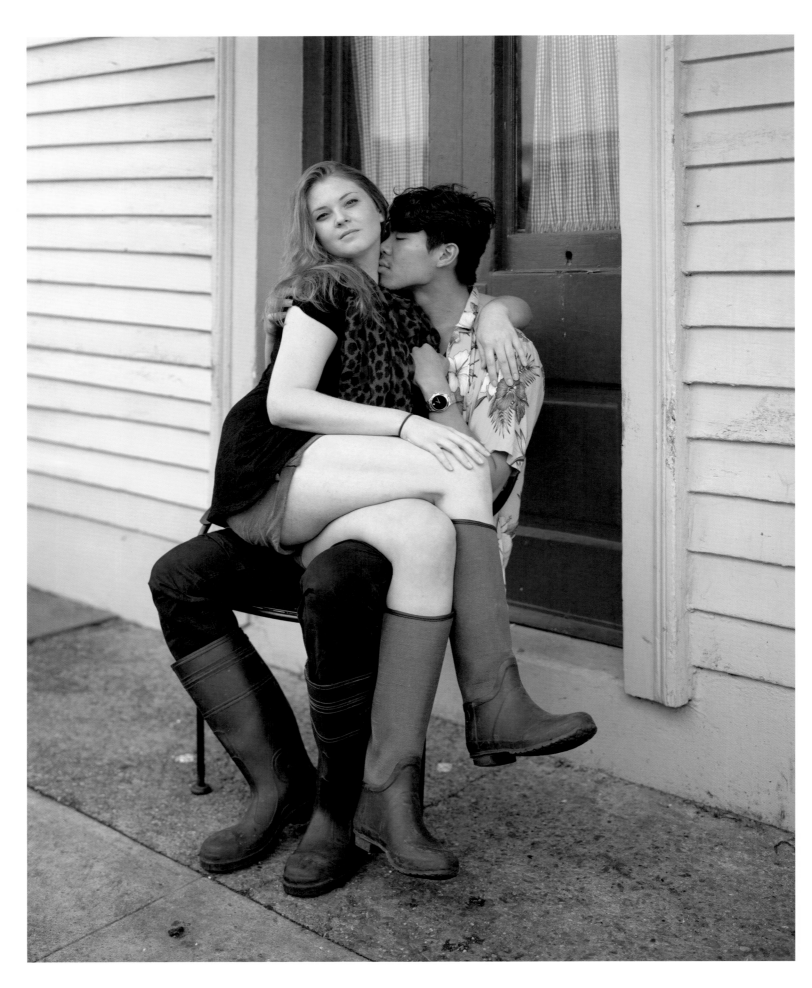

Ashleigh and Tony NEW ORLEANS, LOUISIANA, 2012

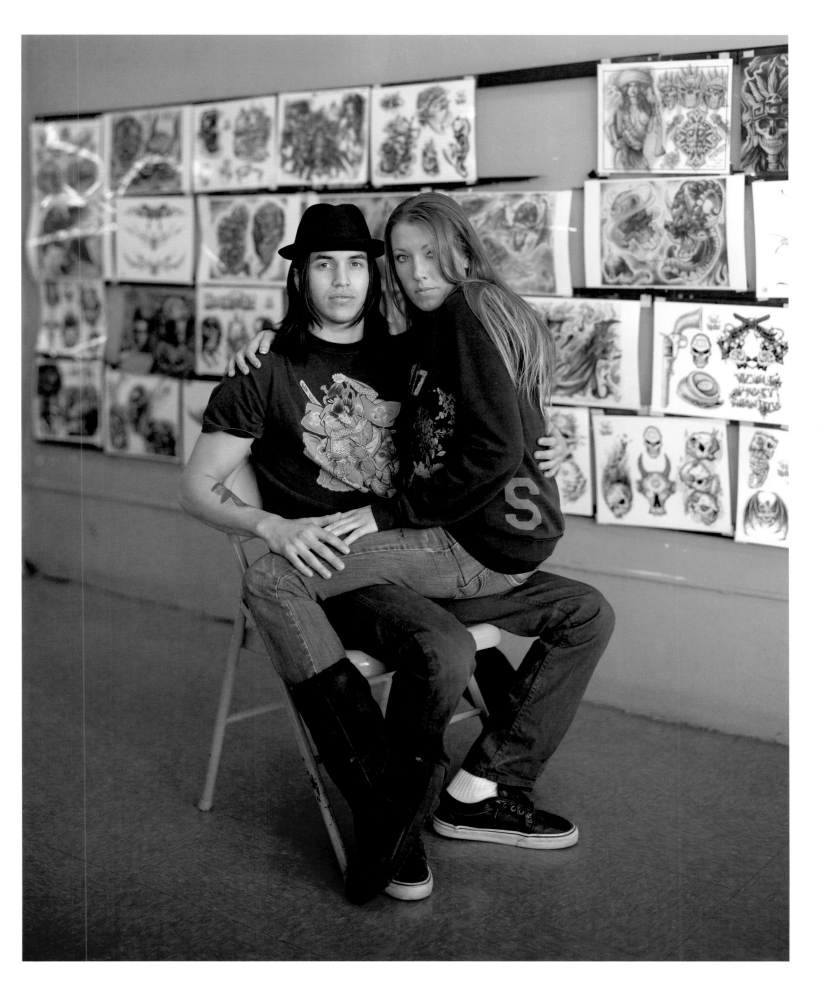

Keebs and Beth   LAS VEGAS, NEVADA, 2012

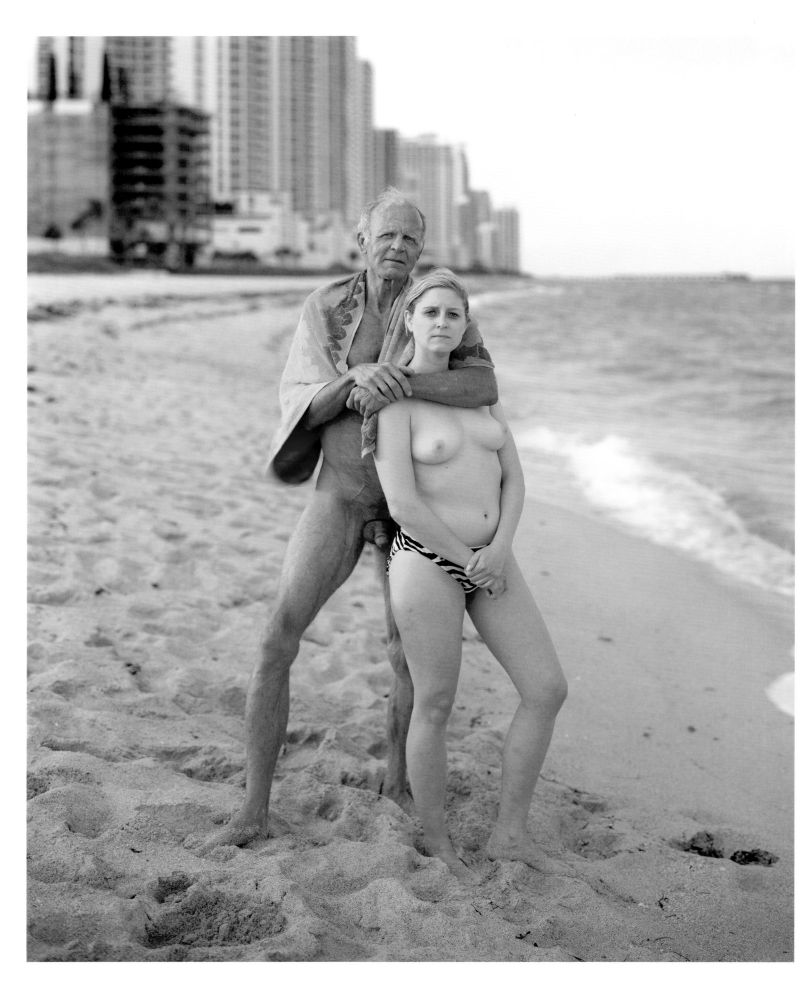

Lee and Lindsey   BAL HARBOUR, FLORIDA, 2011

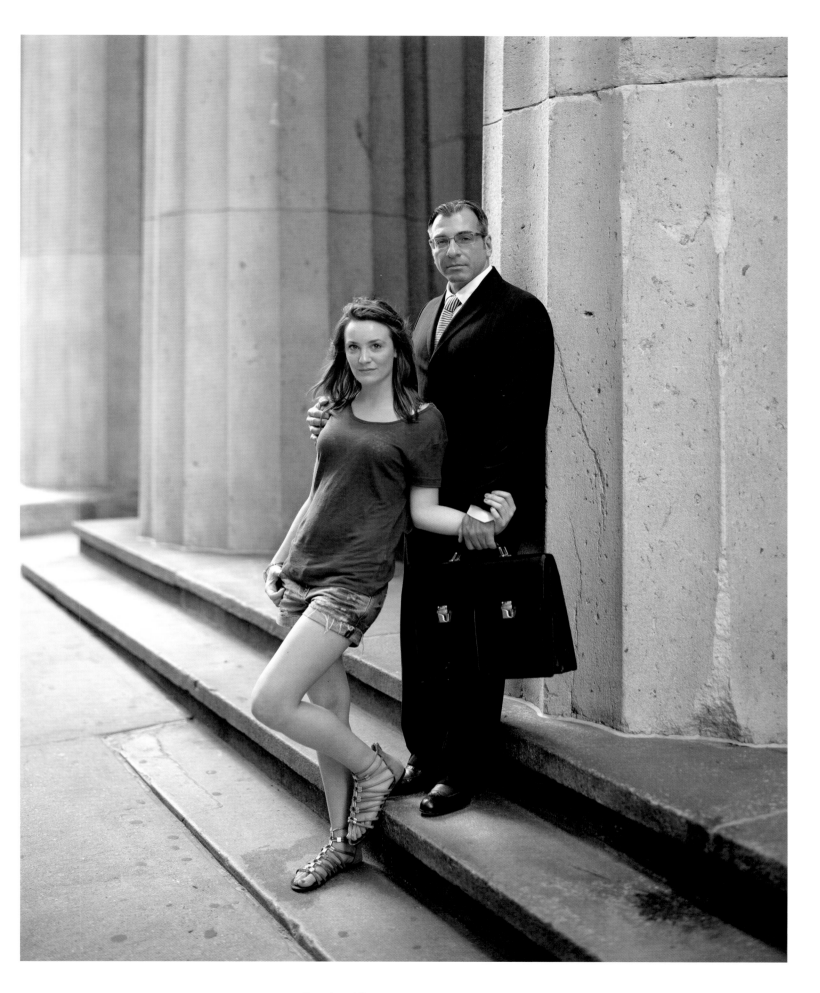

Naomi and Bruce   NEW YORK, NEW YORK, 2011

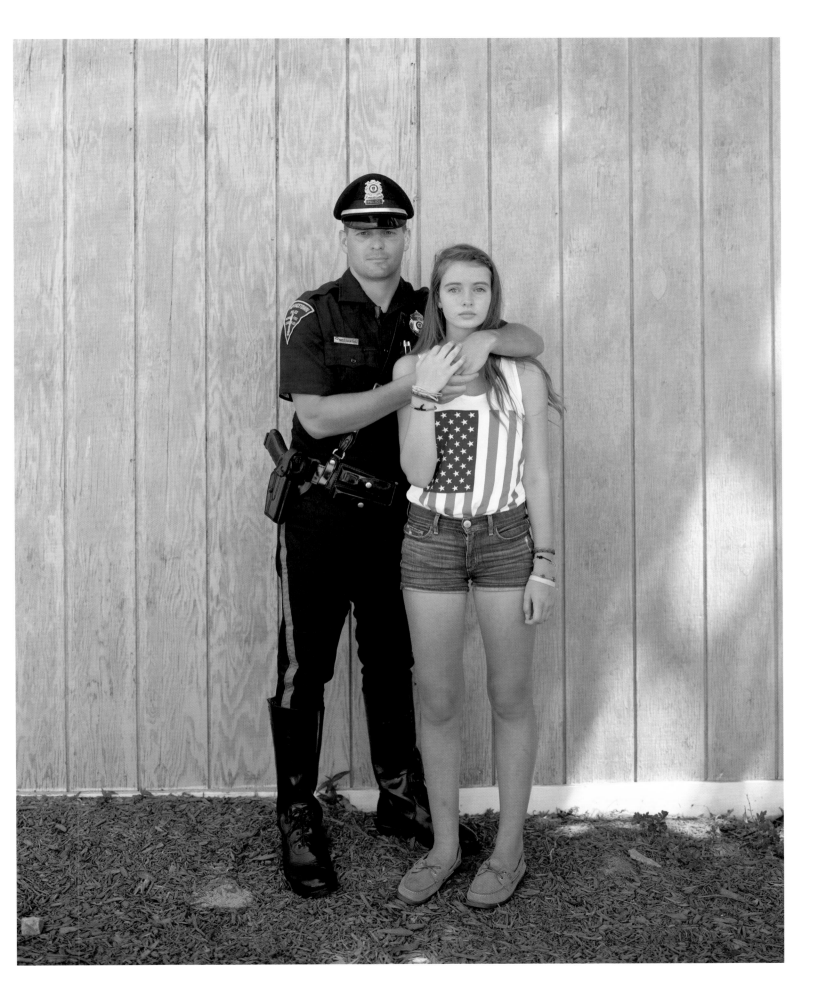

Nathan and Robyn  PROVINCETOWN, MASSACHUSETTS, 2012

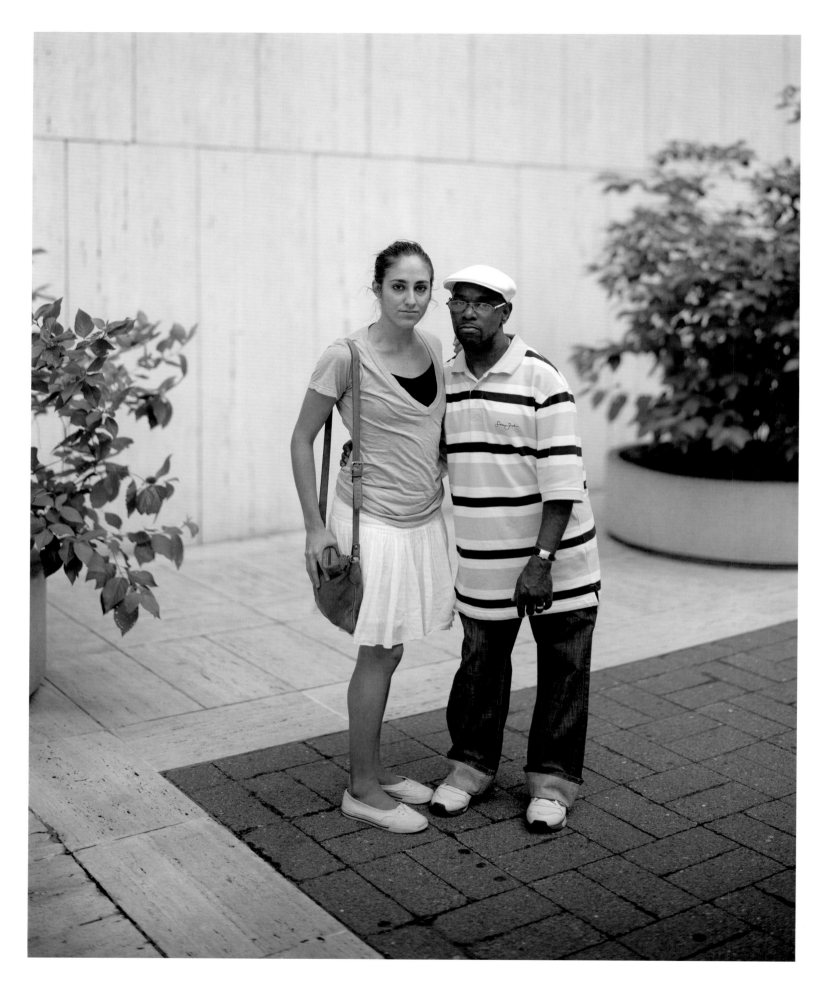

Maria and V  NEW YORK, NEW YORK, 2009

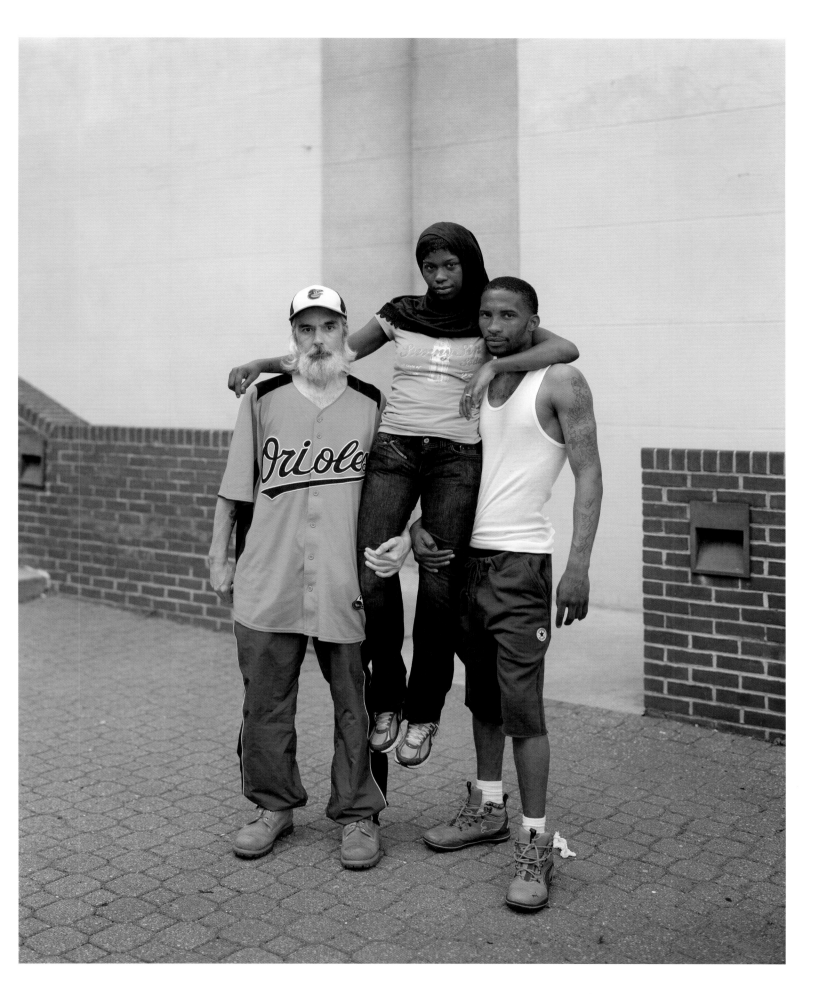

Rodney, Raynesha, and Anonymous   BALTIMORE, MARYLAND, 2013

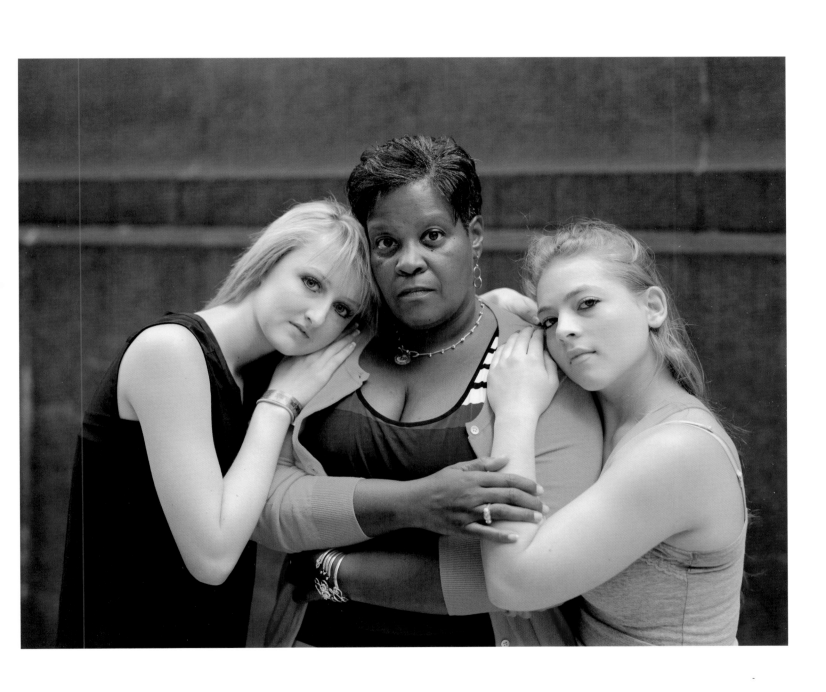

Hunter, Margaret, and Abigail   NEW YORK, NEW YORK, 2013

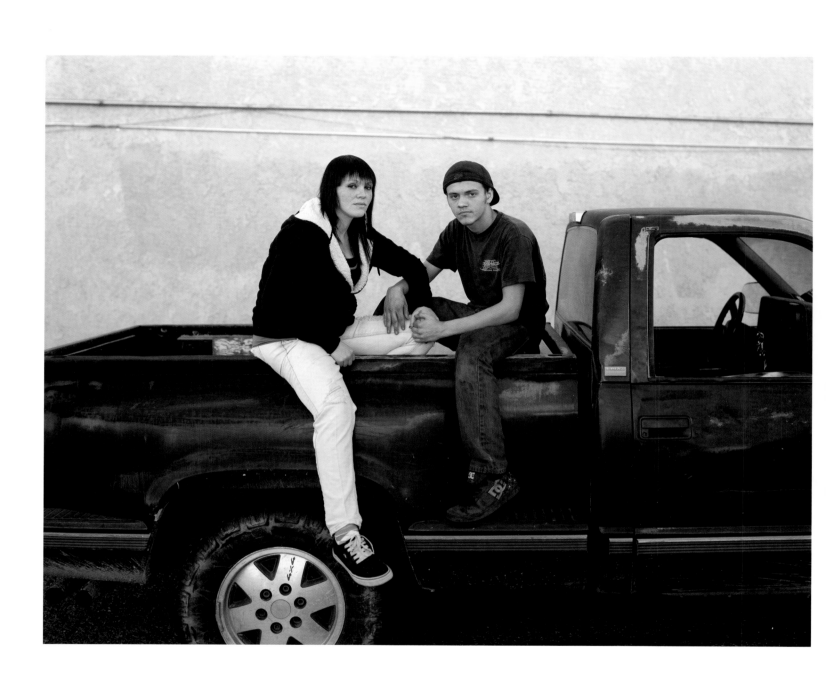

Krystal and Greg   PARKER, ARIZONA, 2012

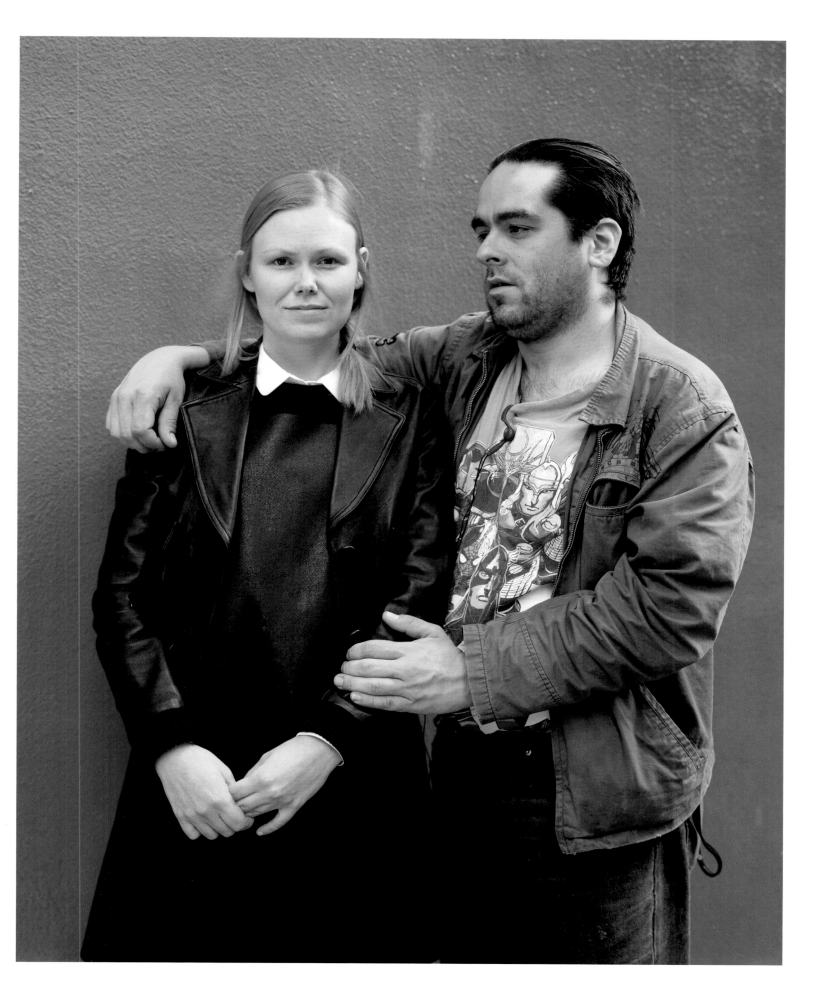

Heather and Johnny  SAN FRANCISCO, CALIFORNIA, 2012

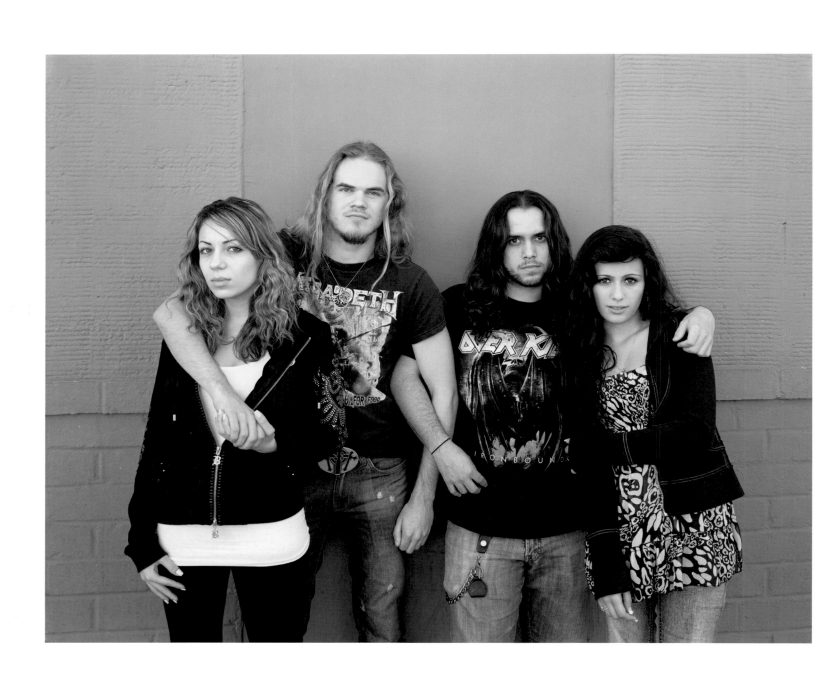

Angie, Steve, Edward, and Maria  HOLLYWOOD, CALIFORNIA, 2012

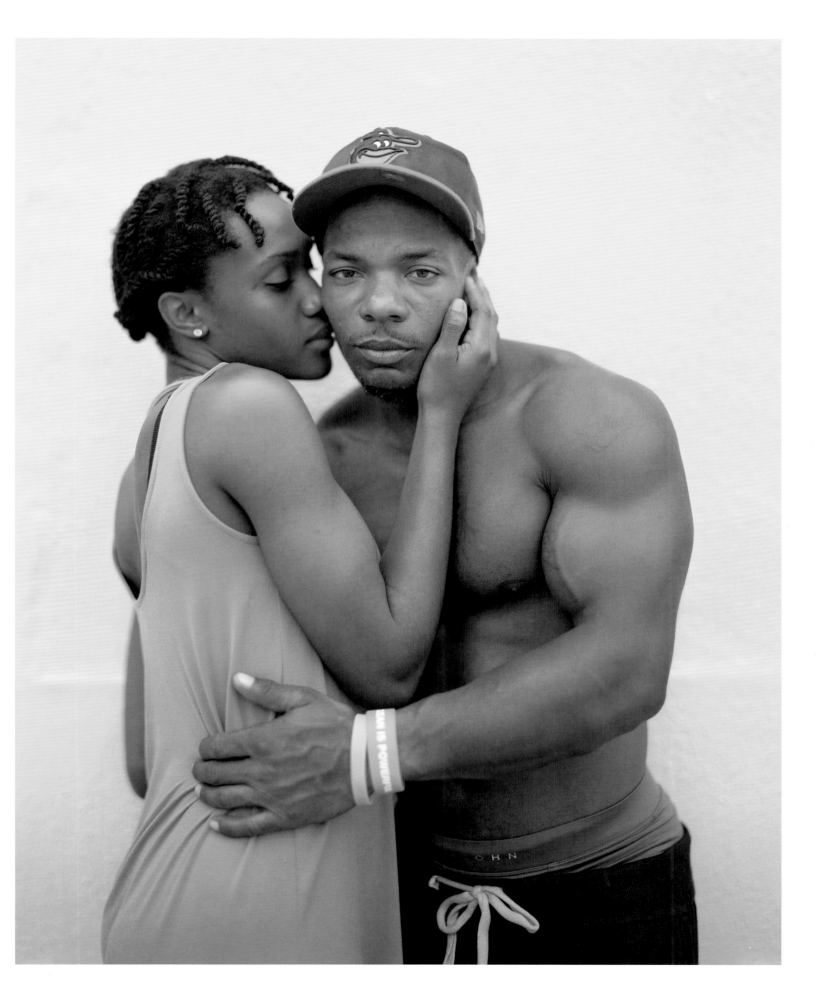

Ekeabong and Andrew   VENICE, CALIFORNIA, 2013

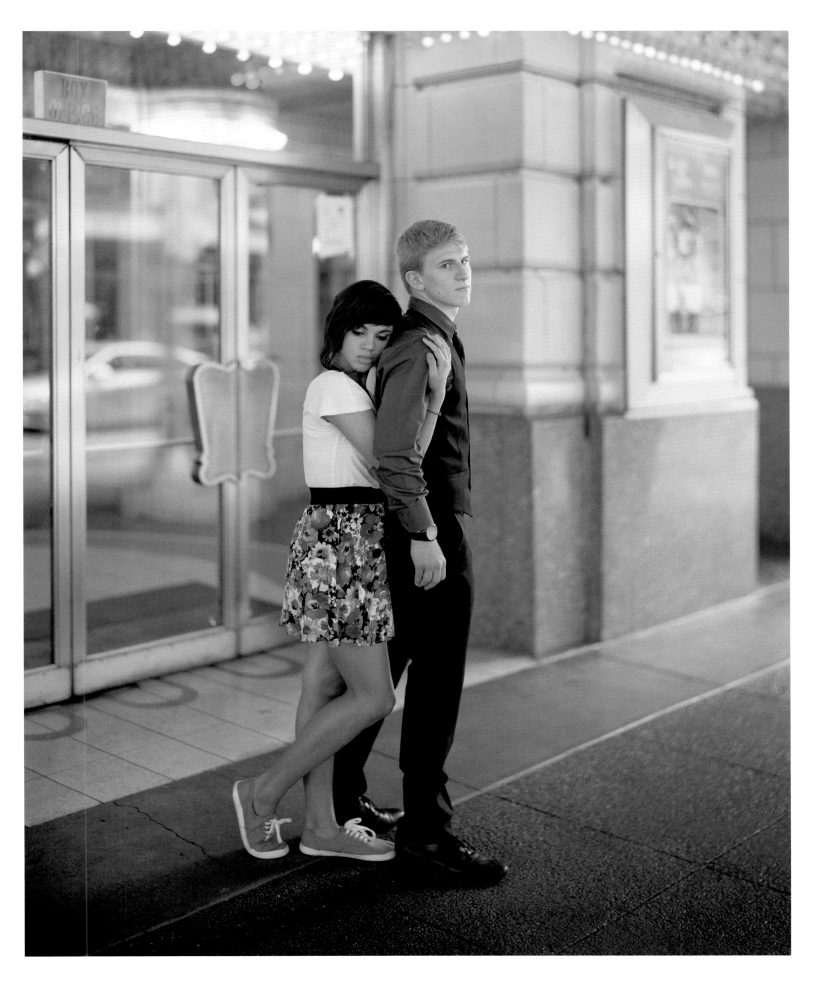

Tiana and Gunnar  CHICAGO, ILLINOIS, 2013

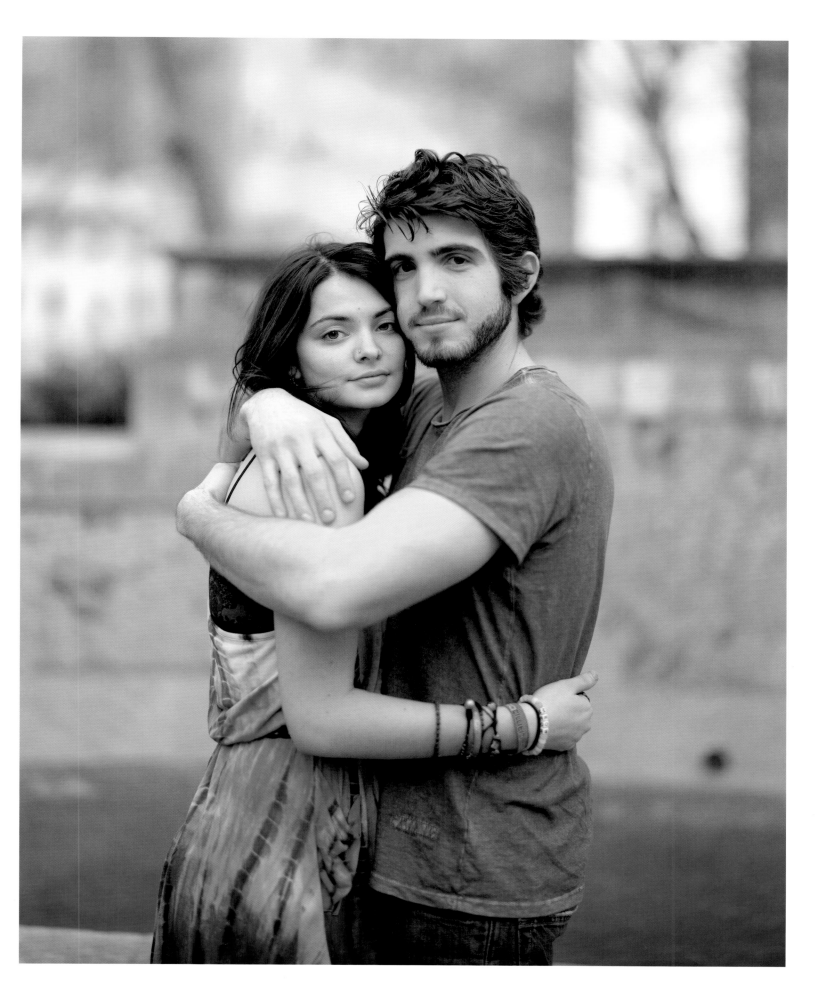

Janaki and Dominic   PHILADELPHIA, PENNSYLVANIA, 2013

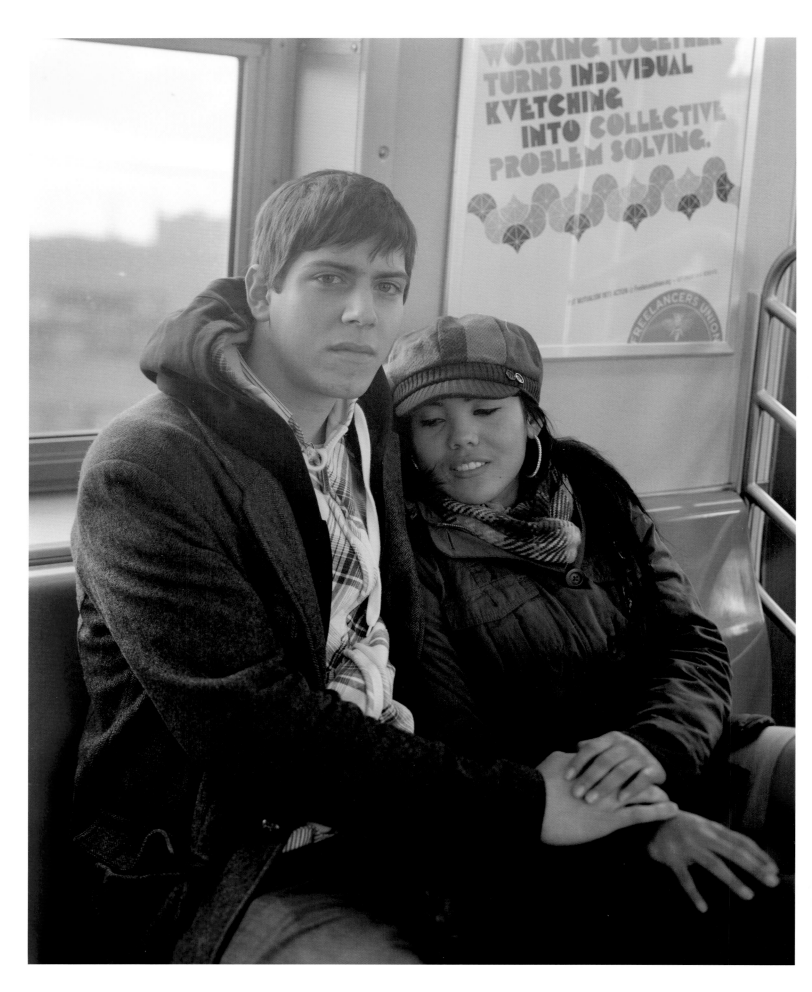

Michal and Sarah  NEW YORK, NEW YORK, 2011

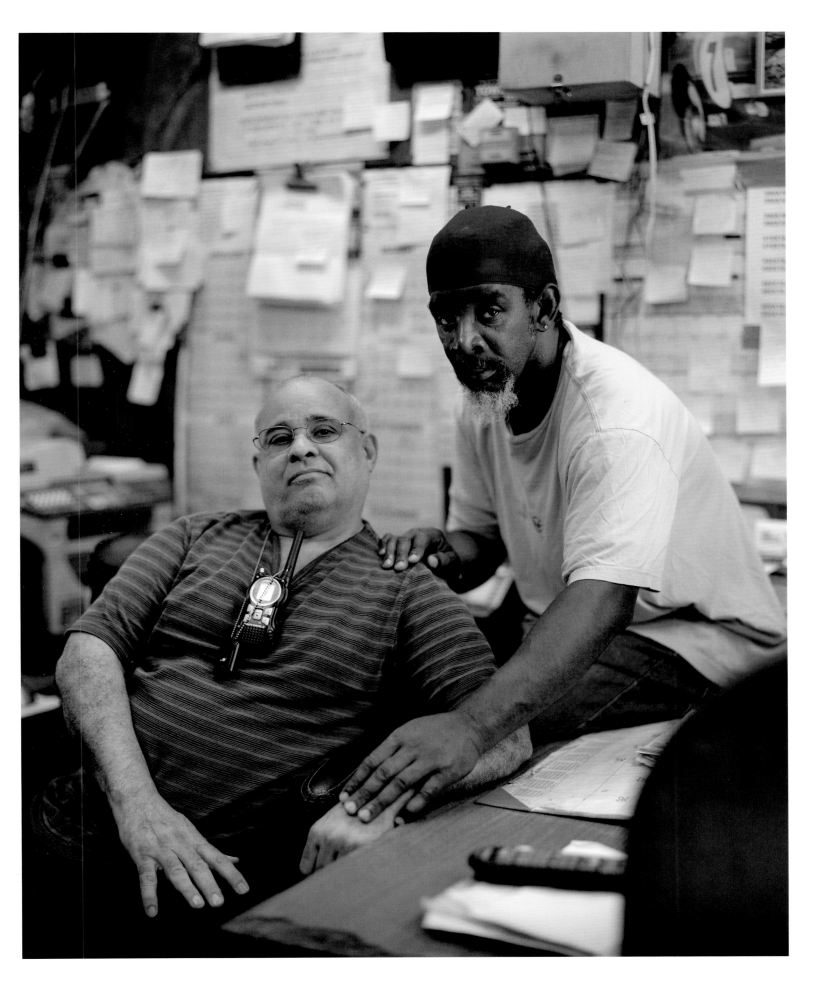

Pedro and Neal   NEW YORK, NEW YORK, 2011

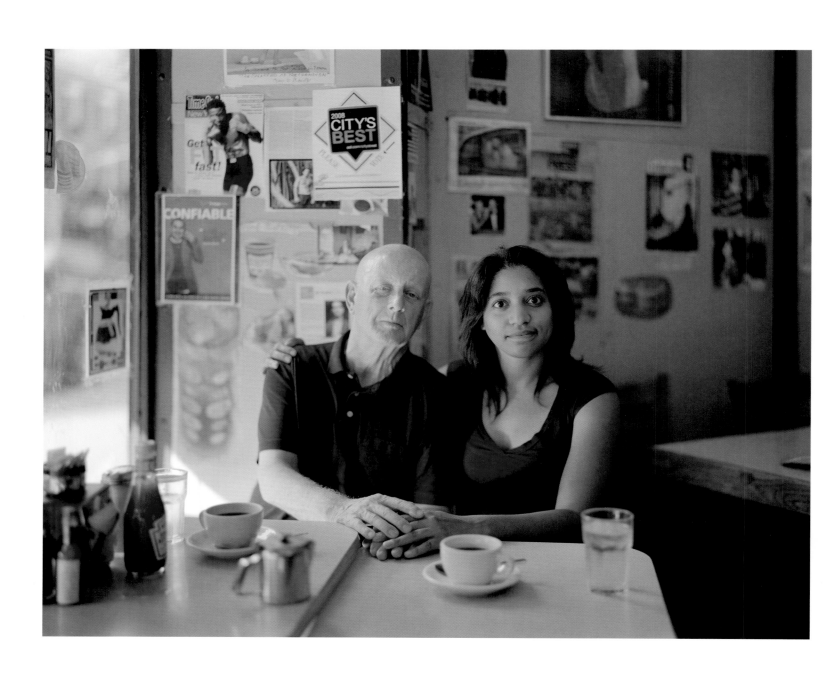

William and Felice NEW YORK, NEW YORK, 2008

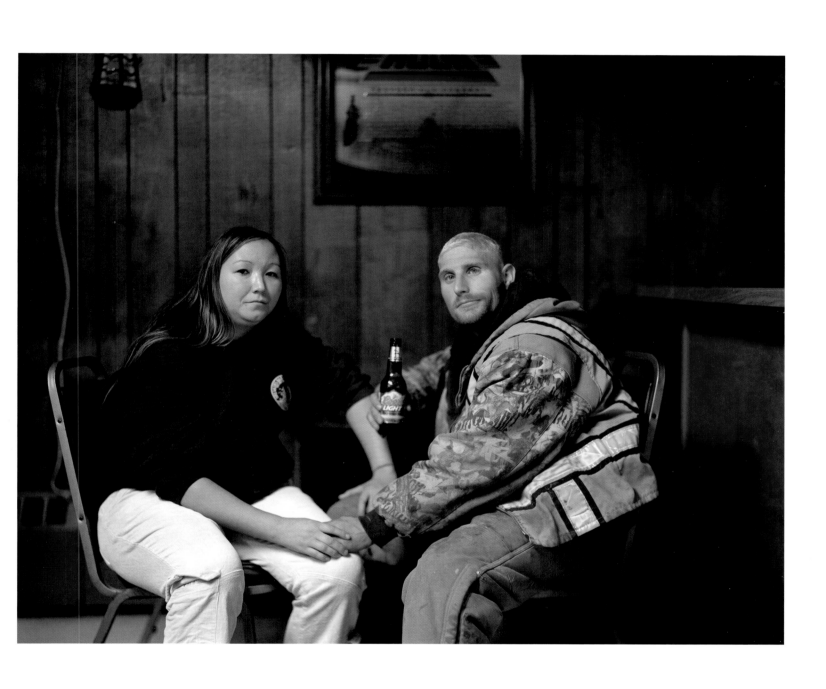

Jeanette and Alan  NOME, ALASKA, 2010

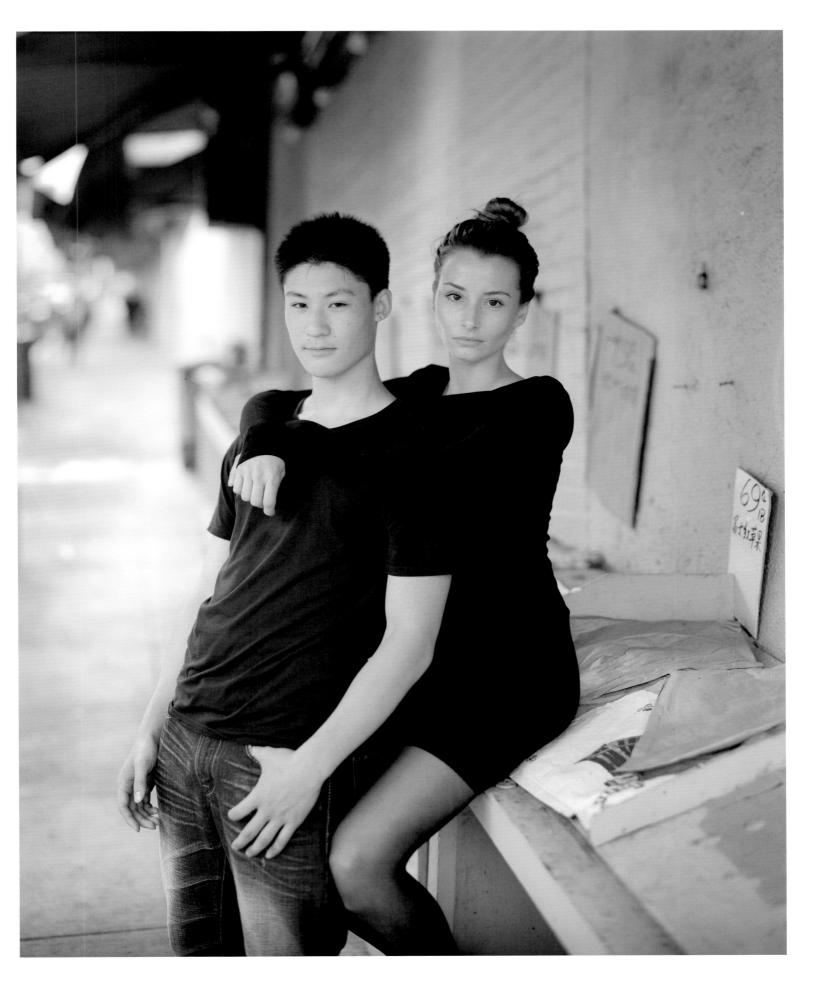

Henri and Natalie SAN FRANCISCO, CALIFORNIA, 2012

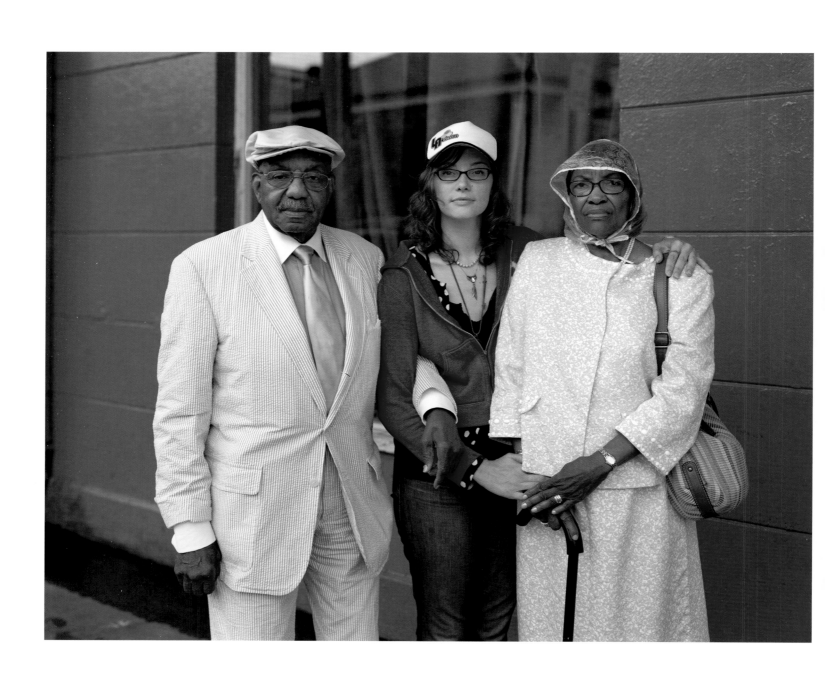

Orville, Rebecca, and Joyce  NEW ORLEANS, LOUISIANA, 2012

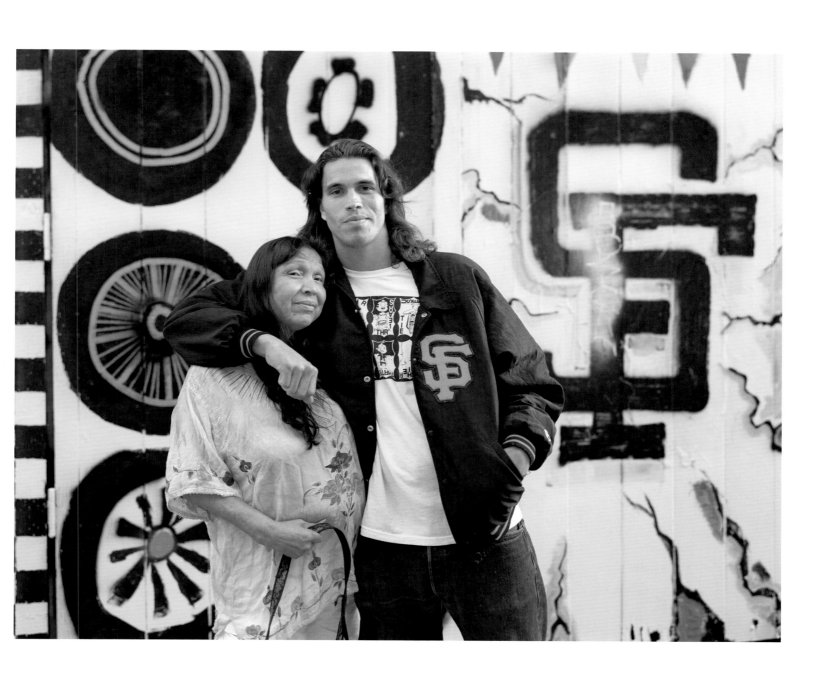

Lola and Jacob  SAN FRANCISCO, CALIFORNIA, 2012

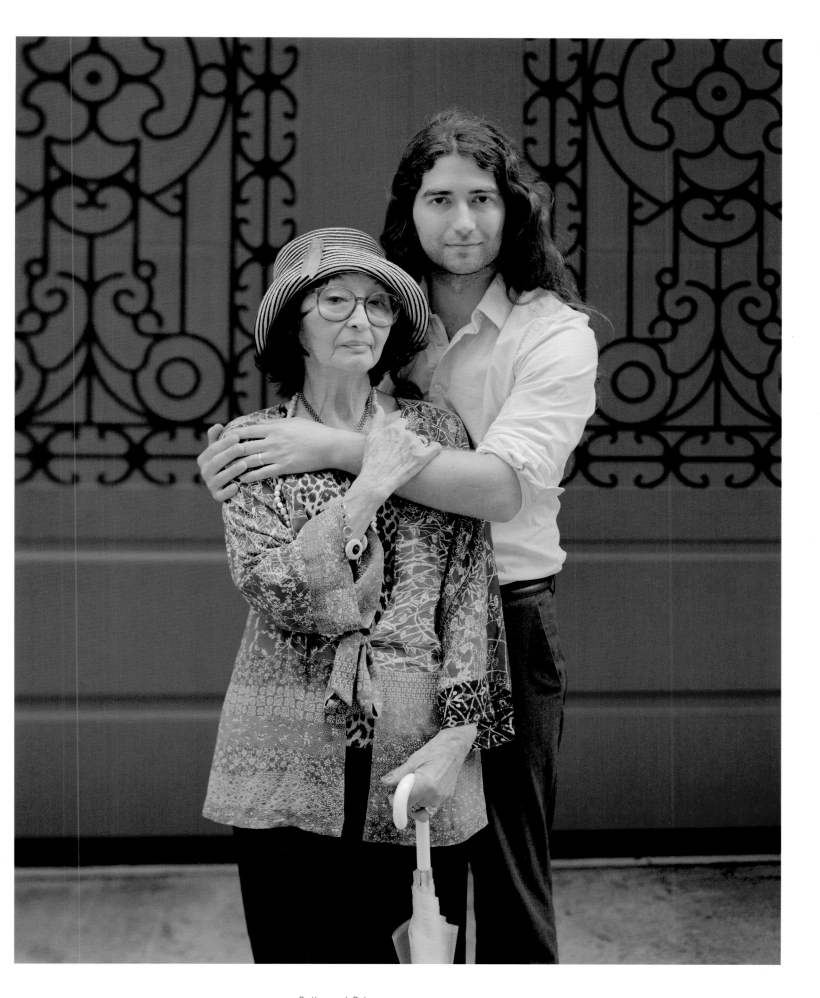

Reiko and Brian   NEW YORK, NEW YORK, 2013

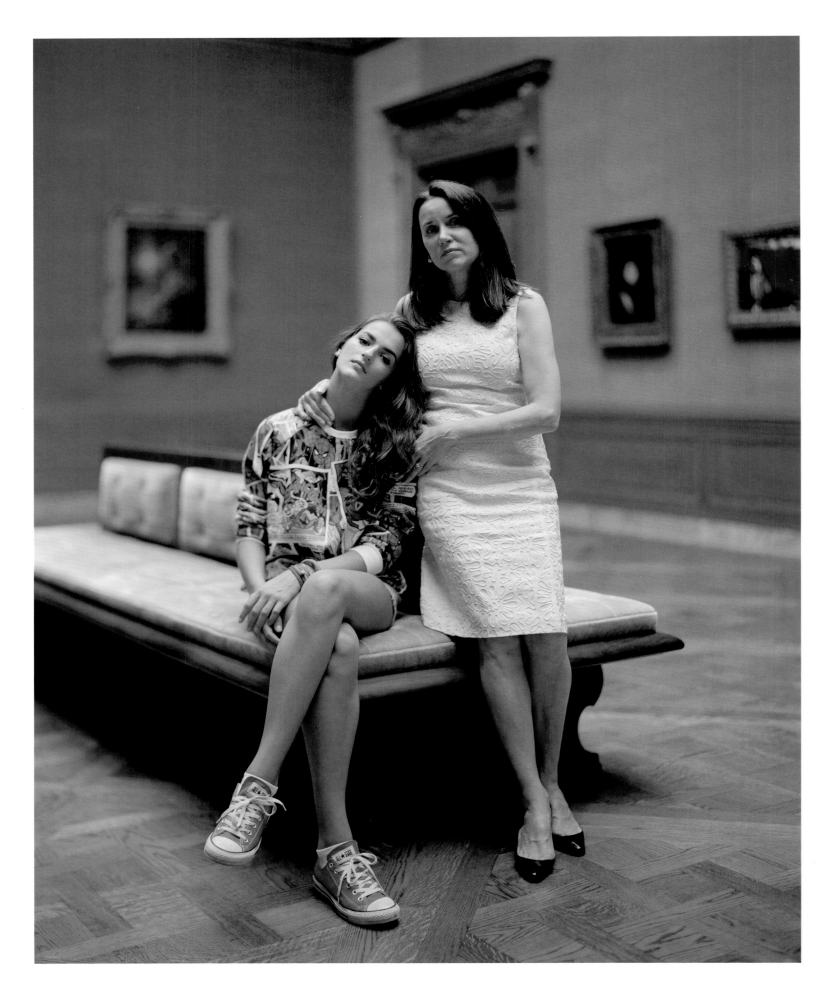

Mila and Janice  NEW YORK, NEW YORK, 2013

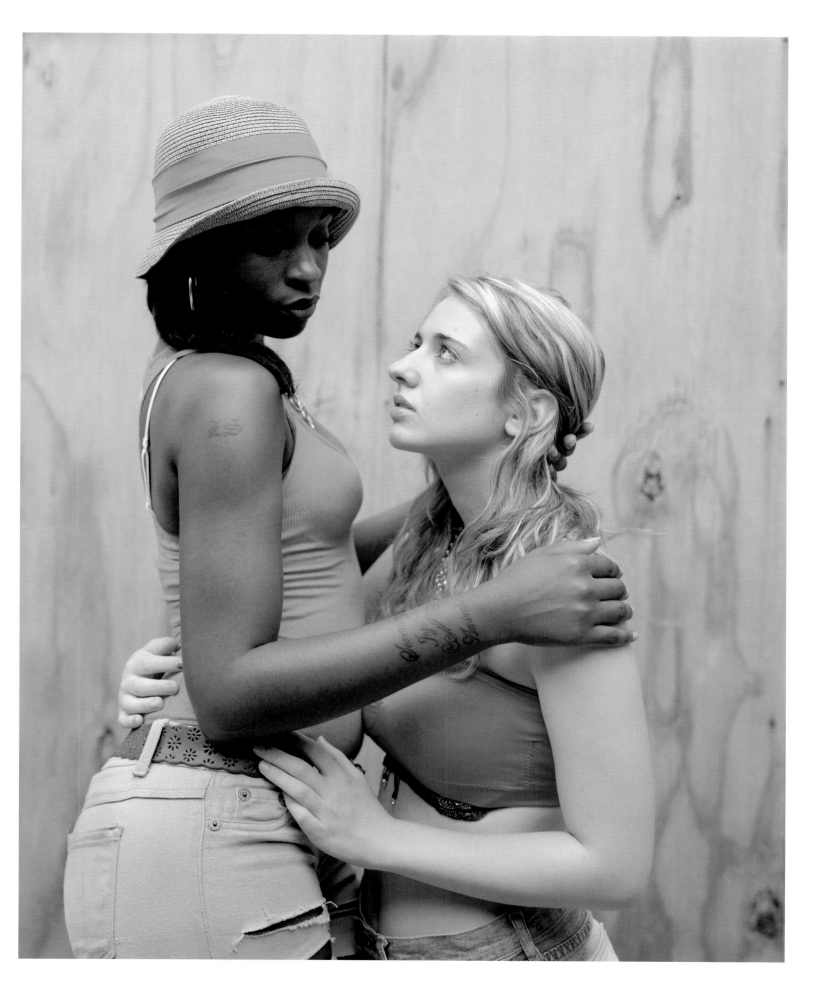

LeAsia and Rebecca   NEW YORK, NEW YORK, 2013

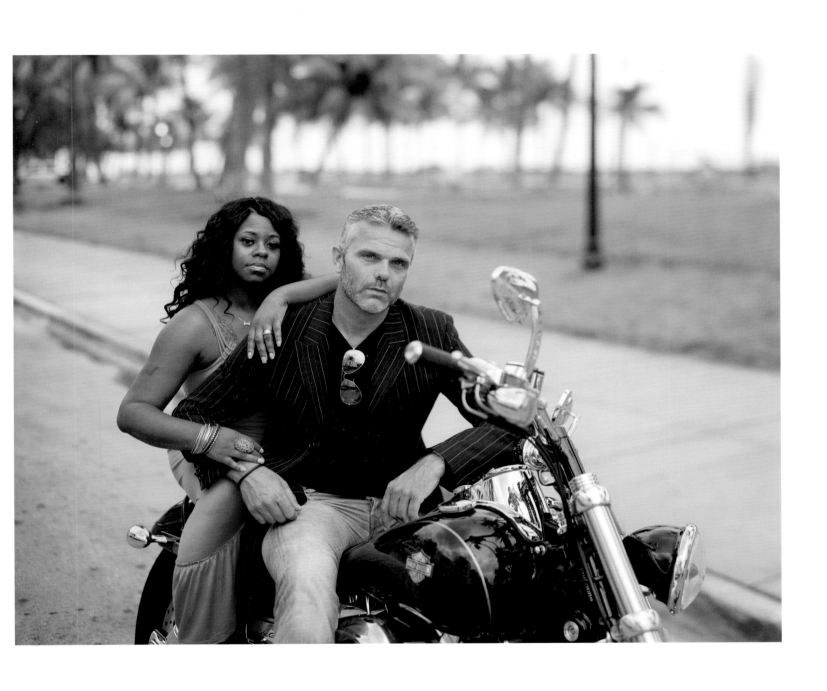

Jenelle and Fabrice   MIAMI BEACH, FLORIDA, 2011

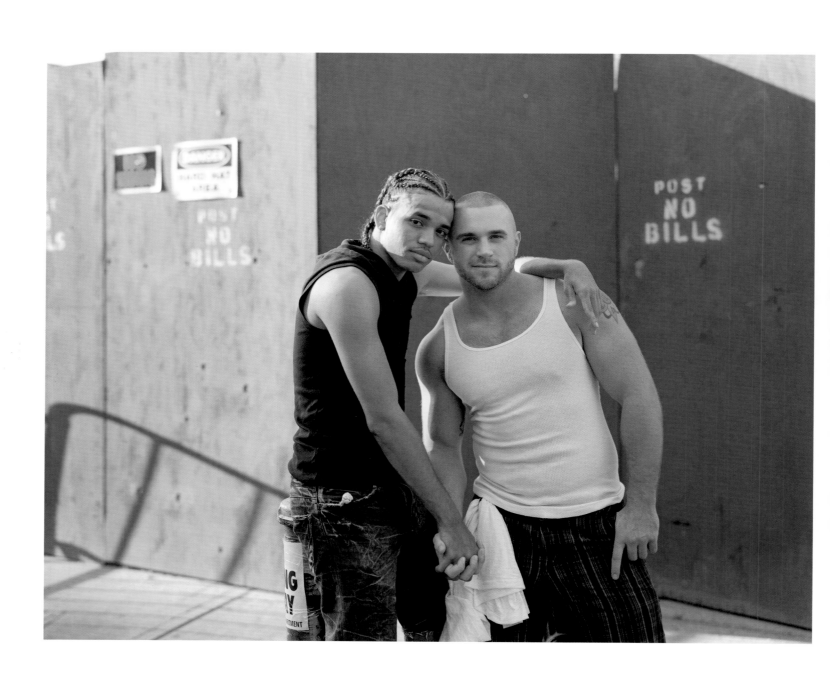

Michael and Jared NEW YORK, NEW YORK, 2011

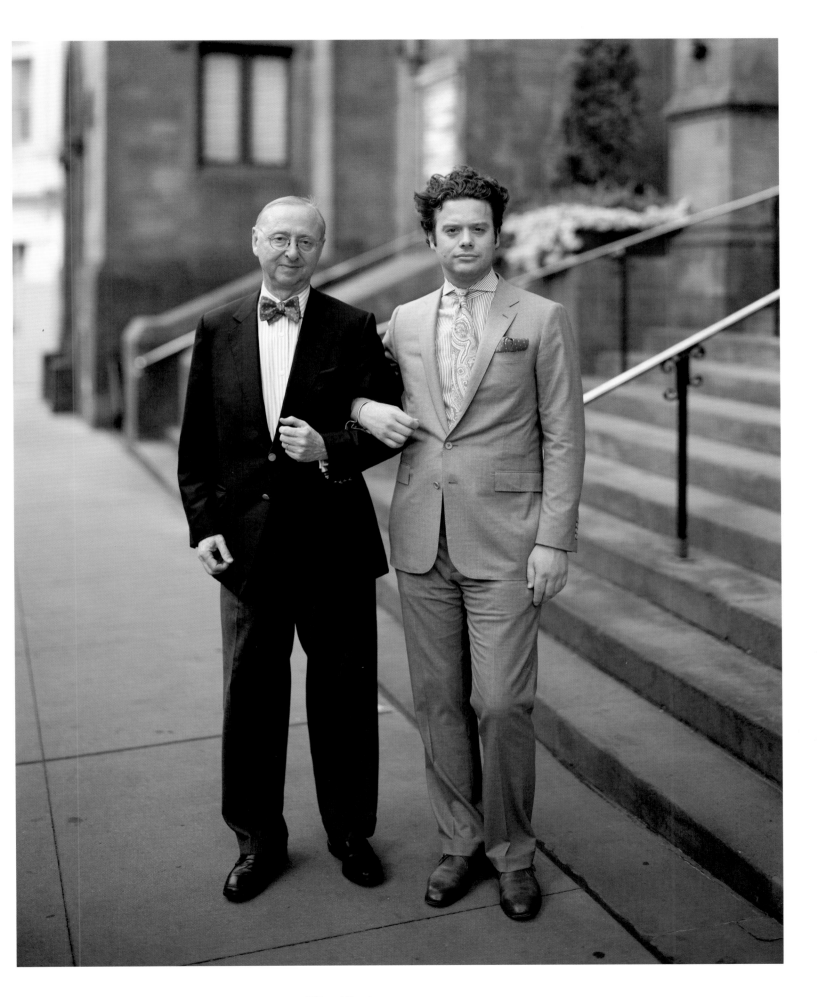

Bill and Travis   NEW YORK, NEW YORK, 2012

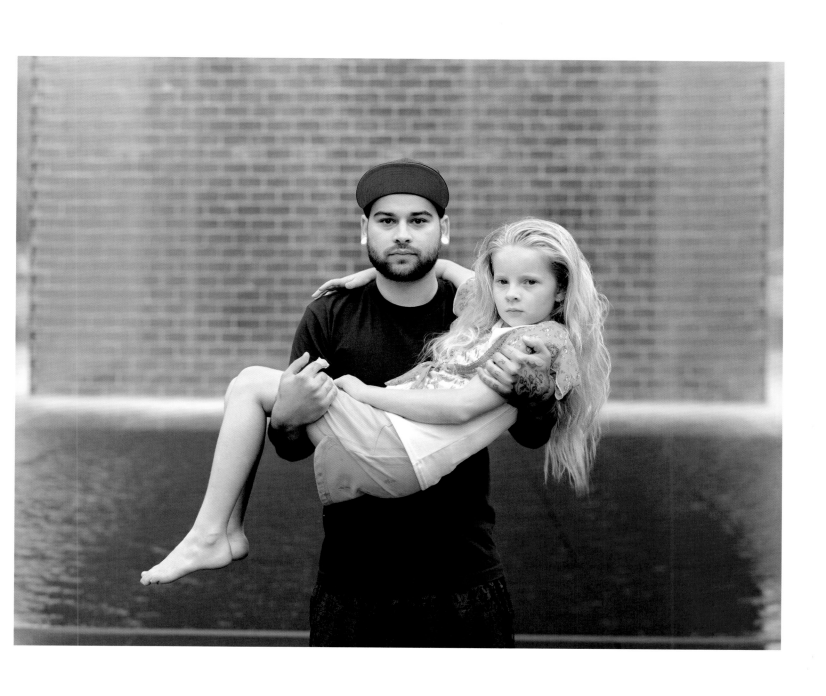

Chris and Amaira   CHICAGO, ILLINOIS, 2013

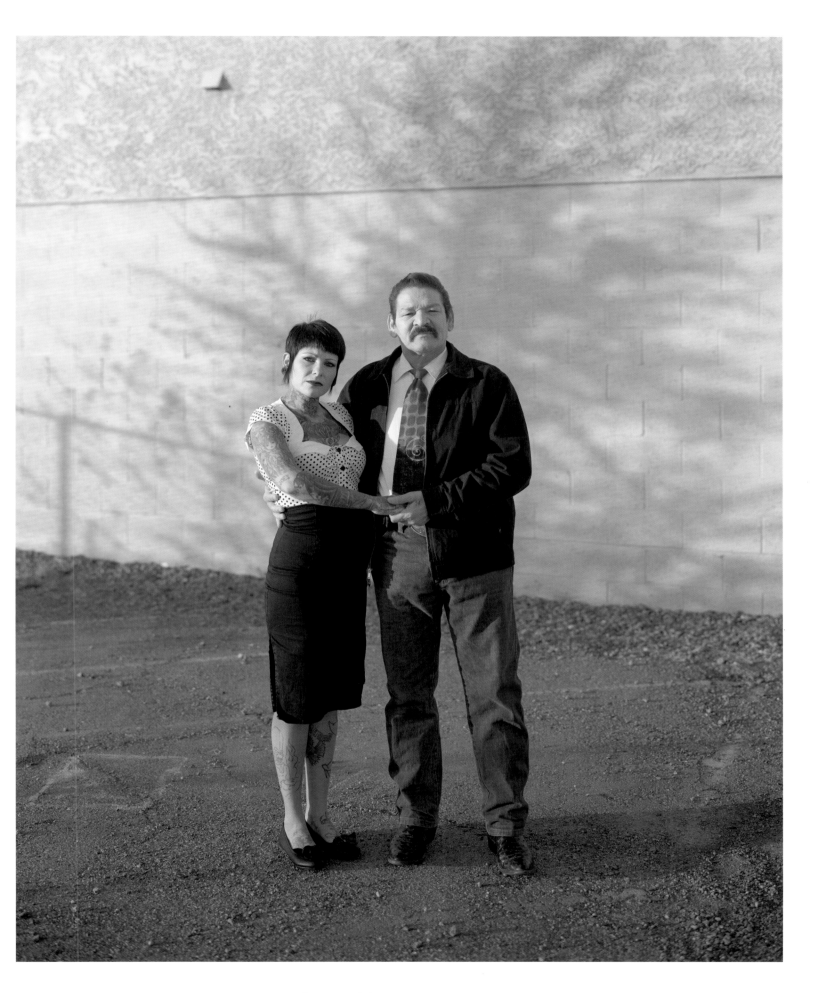

Josette and Juan   LAS VEGAS, NEVADA, 2012

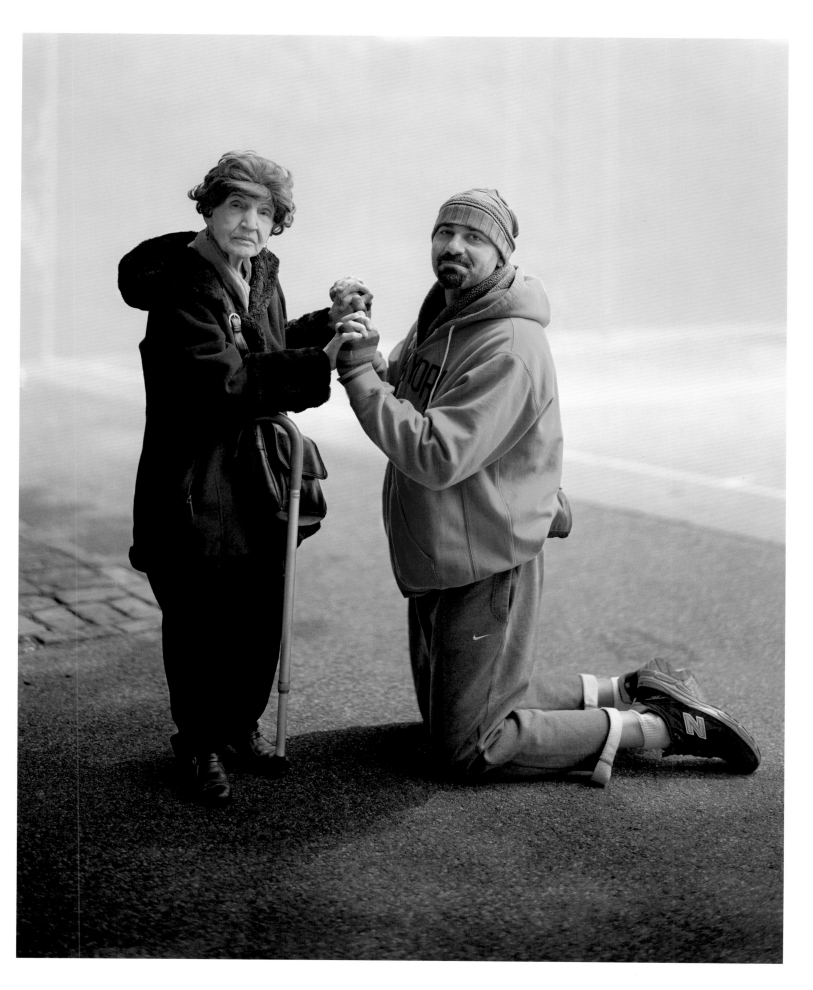

Jessie and Michael  NEW YORK, NEW YORK, 2013

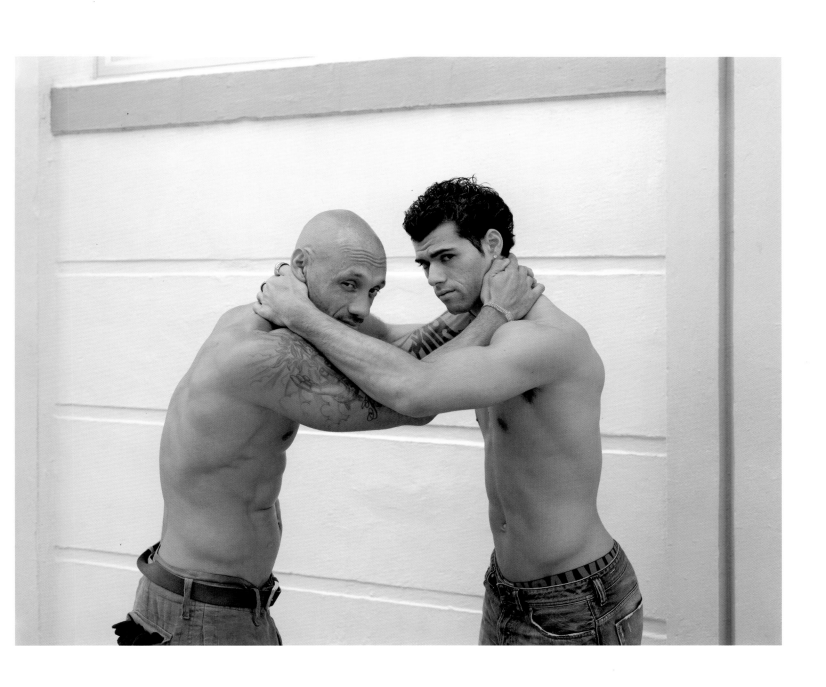

Gerry and Gian Michael   MIAMI BEACH, FLORIDA, 2011

# AFTERWORD BY RICHARD RENALDI

During Sunday services at the parish church my family occasionally attended in the 1970s, we were asked to do something that I remember being out of the ordinary. The priest would ask us to turn to the strangers seated beside us and offer a sign of peace in the form of a handshake. I looked forward to that part of the service. I remember feeling connected to something larger than my immediate family, which would soon be broken apart by my parents' divorce.

Handshaking is at least as old as the ancient world and is thought to have originated as a gesture of nonviolence, demonstrating that the hand held no weapon. An 1864 engraving apocryphally depicts the Native Americans shaking hands with Puritan colonists arriving at Plymouth. Throughout the nineteenth century, Quakers popularized handshaking as a sign of equality under God. I did not know it then, but I was participating in one of the few primeval customs in which it was permissible to put my hands on the body of an unfamiliar person. Those Sundays at church are my earliest memories of touching strangers.

I spent my teenage years in Chicago, living alone with my mother in a high-rise apartment building along a stretch of Lake Shore Drive known as the "Gold Coast." There was a clear distinction between our wealthy neighborhood and Cabrini-Green, the notorious housing projects less than a mile away. Though I was too young to fully understand America's history of racial division, something seemed unfair when my mother took a pen and drew a line on a map that I was forbidden to cross. I didn't know why I was allowed to attend public school with children who lived in the projects, or why we shared the same grocery store just blocks away, yet I was not permitted to enter their neighborhood.

Each of us engages in a private cartography, the fence posts of which are known only to ourselves. Of all the boundaries that separate us from each other, few are more sacrosanct than the invisible lines we habitually draw between others and ourselves in public. The American notion of personal space is relatively unique. Our tolerance for travel

by crowded airplane, bus, or train is low. Large houses and vehicles and a sprawling view to the horizon have come to define the American self-image. Incursions into our personal spaces now summon the phantom pain of a lost sense of entitlement to the endlessness of the land. There are few small-bore offenses in modern life that cause greater affront than a violation of this space. On a crowded subway at rush hour, do you move your leg if it comes into contact with a stranger's?

When I was fourteen, I started sneaking out to gay cruising spots in downtown Chicago looking for discreet sexual encounters. I was most often the aggressor and sought out men nearly twice my age. Driven to discard everything I had been told about the threat of strangers, I began to construct elaborate fictions regarding my whereabouts, the people I was associating with, and the nature of my relationships. I wanted a physical connection, but I also felt the desire for friendship and affection that I believed weren't possible living a double life. Occasionally, men would take me home and afterward want to hold me, touching my body in a tender manner that helped me understand not only palpable desire, but the experience, however brief, of a kind of love between strangers.

Urban life forces us into shared spaces with members of other tribes, and out of this circumstantial density we create a larger family for ourselves, however dysfunctional. At an early age, unseen connections between strangers in the city, and the negative space between them, became visible to me as the singular adhesive tissue linking communities, binding each of us together into small universes, unaware of the power of each other's gravitational pull.

Early in my career as a photographer, I discovered that the fearlessness I had acquired in approaching strange men suited me well in my work as a street portraitist. I had a talent for casting strangers, suffering little awkwardness when self-tasked with approaching them for a picture.

Asking strangers for photographs elicits reactions along a spectrum, as if one had proposed something either as anodyne as sharing a cup of coffee, or requested a spontaneous and public sexual favor.

In my first book, *Figure and Ground*, I sought out subjects with whom I had little in common geographically and culturally: bull riders in Nevada; members of the Navajo and Sioux nations of the central plains and Southwest; the urban poor I met on the streets of decaying, former industrial cities of the Northeast. Structured as a journey across America, *Figure and Ground* was a composite of dozens of road trips documenting a nation in the perpetual throes of questioning itself morally and economically at the turn of a new century.

In 2004 I began a series of portraits titled See America by Bus. I traveled to Greyhound stations across the country documenting a grueling subculture of transcontinental bus travel. Framing my subjects inside these harshly lit purgatories, I hoped to connect with the traveling dreamers for whom the promise of America had proven illusory. It was on the long, communal benches of these transitory spaces that I first confronted the unusual circumstance of asking people who were strangers to each other to pose together in one of my portraits. The challenge of coordinating two or more strangers in the same image appealed to me, and in considering how I could expand on the theme, I thought of this: What would happen if I asked people to touch one another? The question became the genesis of *Touching Strangers*.

I wanted to know what would happen if I asked my subjects to reach through and beyond their taboos. I wanted to observe the physical vocabulary that would emerge when a photographer directs strangers who have been approached randomly on the street, and who have been introduced to each other only moments before, to touch each other's bodies. The notion of breaching these boundaries struck a powerful chord with me, resonating from my childhood and connecting *Touching Strangers* to much of the photographic work I had previously made.

On my first outing in the summer of 2007, I met a woman named Ilene who reluctantly agreed to participate in one of my first pairings. She suggested that rather than calling the project Strangers Touching—which was my overly literal working title at the time—that I call it Touching Strangers instead. The double entendre appealed to me and I decided to take her advice. The instincts of most strangers when they are initially asked to touch each other's bodies—clearly visible in the portrait of Ilene and Loria (p. 30)—are both tentative and awkward. The most obvious gesture people assume in the absence of direction is to hold hands or to place their arms around each other's shoulders. But I wanted more. I needed to step into the role of director and instruct specific points of contact for many of my collaborators.

Like a stage hypnotist choosing volunteers from an audience, I had to learn to read my subjects' openness to suggestion, and how far they were willing to be pushed. Casting in public is challenging. Even in large cities where the life of the street seems to present nearly unlimited combinations and possibilities, a successful pairing is dependent primarily on serendipity. Initially, I would choose my subjects from amenable passers-by, but as the project moved forward I became more selective. I required a large pool of people from which to draw, seeking to isolate them from the chaotic urban swirl in order to create a kind of rhyme between my collaborators and their backgrounds. The first subject also had to be willing to wait with me until I found them a partner. I lost many opportunities when people simply walked away as I was searching for their companion.

*Touching Strangers* represents my wish to subvert the conventional relationship between photographer and subject by asking participants to submit to the same potential for rejection that I experience canvassing in public. On San Francisco's Twin Peaks, I once asked a woman named Annalee, from South Carolina and with a deep Southern accent, if she would volunteer to be in one of the portraits. She reluctantly agreed, and I

and I went looking for her companion. Moments later, I saw a Muslim woman wearing a *hijab* walking with her husband. I had been trying for years to cast a traditionally dressed Muslim woman, and had always been turned down. I began to wonder if Annalee, waiting in the distance, would see me asking a headscarfed woman and change her mind. I had a notion that Southerners were generally prejudiced against Muslims, and I worried that I was now potentially responsible for subjecting the Muslim woman, who introduced herself as Rayqa, to a painful incidence of intolerance. Rayqa's husband gave her permission to pose for me, but she refused. Dejected, I went looking for another person to pose with Annalee when I heard a shout: "Hey, photographer!" The two women were holding hands. Annalee had intercepted Rayqa, introduced herself, and asked to her to be in the picture with her (p. 15).

Collectively, we still hold fast to the idea of photographs as unambiguous documents of specific events. From the very moment of photography's invention, photographers have been uniquely and unfairly burdened by this naive assumption. A photograph is no more reliable an instrument of truth than the human eye. The moments captured in *Touching Strangers* were orchestrated. They are fictional, spontaneous relationships acted out as street performances in front of my 8-by-10 view camera. The participants did not know each other and may never meet again. And yet, these recorded moments of contact will now permanently exist as connections between two or more human beings, all strangers to each other. On completing one of these photographs, there was often a feeling that something rare and unrepeatable had just occurred.

Viewers of *Touching Strangers* often imagine their own stories about the relationships in the photographs. This is natural and intuitive. The human mind exercises an ancient impulse to delineate the bonds of human interconnection. As someone once wrote to me, "One thing that stood out while looking at your photographs was the stories that I

came up with about their relationships and histories. Even knowing that the people are complete strangers, I still wanted to make sense of who they are to each other."

What was initially for me a sociological experiment is for the viewer often something quite different. Some who have viewed these photographs have been moved to tears. Others find the project disturbing. These two extremes represent unusually intense emotional responses to photography, a medium that is veering away in its contemporary practice from emotional subject matter into ever more esoteric and impenetrable terrain. With this project, it was my hope to inject a new and unpredictable variable into a traditional photographic equation. To argue the case that complex sentimentality can harmoniously coexist with the conceptual.

*Touching Strangers* might well be about my own search for intimacy, my desire to visually articulate and to cross the unseen boundaries that separate us from one another. I wanted to recapture the sentiment that made me eager to feel the touch of those strange hands on Sunday mornings nearly forty years ago; to gauge the potential of every passing stranger to be a lover, a partner, or a friend.

WITH SINCERE THANKS TO ALL THE SUPPORTERS ON KICKSTARTER WHO MADE THIS BOOK POSSIBLE

(A) Aaron and Miriam Silberstein; Abraham Doe; Adam C. Pitula; Adam Sanderson; Adam Ware; Addison Olian Photography; Akos F. Santa; Alan Berkson; Alan Charlesworth; Alejandra Carles-Tolra; Alex Nichols; Alex Worman; Alexa Becker; Alexander Goletz; Alexander Maksik; Alexander Martinelli; Alexander Sauer; Alexandra Wahl; Alexandre Klein; Alexia Koelling; Alicia Audi; Allan Seward; Allen and Gina Brown; Allen Frame; Allen Keith Yee; Althea Champagnie; Alvin Comiter; Aly Wells; Alyssa Alimurung; Alyssa Miserendino; Amanda M. Wacasey; Amanda Theroux; Amani King; Amy Seagram; An Rong Xu; Anders Larsson; Andrew Da Conceicao; Andrew Guidroz II; Andrew Hetherington; Andrew Jon Martin; Andrew Magnes; Andrew Miksys; Andrew P. Cuddy; Andrew Whitehouse; Angela Yonke; Angie Kalea Ho; Ania Galka; Anita and Ken Colburn; Anita D. Hicks; Anita Tótha; Anjali Pinto; Ann and Edmond Soldz; Ann Renaldi; Anna and Christopher Kliner; Annalisa Barrie; Anne Aghion; Anne Driscoll; Anne Giraud; Annette Soodhalter; Annette Völckner; Annie Appel; Antony Sojka; Ari Bezman; Ari Zelunka; Arne Heldal; Aron J. Estaver; Ashlee Hodor; Ashley and Joel Barhamand; Ashley Simpson; Audrey A. Heller; Aviv Schwietzer (B) Barbara Griffin; Barbie K. Schrick; Barry Benjamin; Becca DuPree; Ben Crawford; Ben Fleis; Ben Huff; Ben Salesse; Ben Spahbod; Benjamin Farren; Benjamin Iluzada; Bernadette D'Alessandro; Bernd Warren Becker; Beth D. Clary; Beth Zink; Bethany Sumner; Betsey Kauffman; Bibhu and Yana Mohanty; Bill Kelly; Bill Westerman; Bjorn Kristiansen; Blaine; Bob, Jamie, Emma, and Sophie Therrien; Bobby Davin; Bodie Davis; Bonnie Serkin and Will Emery; Brad Brisken; Brad J. Dameron; Bradley Ryan Curran; Brandee Anderson; Breanne Fite; Bree Mayhew; Brian and Pamela G. Anders; Brian Connolly; Brian Ellner; Brian Hetherington; Brian Messana; Brian Paul Clamp; Brian Virgo; Bruce Christopher Carr; Bruce Hermann and Thomas Goryeb; Bruce Jackson; Bruce Mack (C) C. David Claudon; Caitlin Margaret Kelly; Caitlin Toombs; Calbee Mundy; Caleb Cole; Camille Martínez; Carl Anhalt; Carles Guillot; Carlos Danger; Carlos Loret de Mola; Carol B. Swyer; Carol Sarosik; Caroline Culbert; Carolyn Drake; Carolyn Meyer; Cate Fallon; Cathleen Newsham; Cathy Schacher; Chad C. Breckenridge; Chad Smith; Chandra Jessee; Chantal Heijnen; Charles Jacons; Charles Tomaras; Cherie Jarvi; Cheryl Fisher; Chet Clem; ChiM; Chin-Shan Chuang; Chloe Cerwinka; Chris and Kami Niehoff; Chris Boot; Chris Carley; Chris Harris; Chris P. Nielsen; Christian Koehler-Johansen; Christina Heinle; Christoph Bolten; Christopher Borrok; Christopher English; Christopher T. Rhodes; Christopher Tran; Cindy and Gary Iverson, Letterpress Central; Cindy Dubielak; Cindy Nola Seger; Clara Braddick; Clark Hummell; Cleo Brekelmans; Colleen Hart; Conor MacBride; Constance Brinkley; Cool Hunting; Cory Lovett; Craig M. Smith; Craig W. Myers; Curtis Hawkins; Cynthia Eustice LaPier; Cynthia Kohlmiller; Cynthia Lawson Jaramillo (D) Dalal Al-Mutawa; Dallas Graham; Dan Buzovi; Dan Remus; Dana Lixenberg; Dana M. Pizzo; Daniel and Victoria Bischoff; Daniel Cronin; Daniel Diamond; Daniel J. Gregory; Daniel J. Cardon; Daniel J. Fitzgerald; Daniel Mirer; Daniel Red; Daniel Urdzik; Danielle Thorpe and Ronan Kalb; Dannielle and JP Kyrillos; Daron Larson; Darrel Noel and Miguel Reyes; Dave and Ivana Gibson; Dave Dresden; Dave Haier; Dave Hammaker; David A. Whitney; David Boyd; David C. Potts; David F. Gallagher; David Harirman; David LeVine; David Patterson; David Walor; David Yip; Dawn O'Brien; Dawn Oshima; Dawn Reshen-Doty; Debbie

Bender; Debbie Frati-Hepper; Debby Ruth and Tim Lenz; Deborah Goodman Davis; Deidre Schoo; Deirdre Donohue; Deniz Durmus; Derek B. Grant; Diana Enriquez; Diana R. Krueger; Diana R. Morris; Diane Gordon; Diane Sloan; Diego Sierralta; DJ Markwell; Doc List; Dominic; Dominic Poon; Don Parsisson; Dorothy Lyman; Doug DuBois; Doug Evans; Doug Frank; Doug Frost; Douglas·Nielsen; Dr. Vance McPhail; Drew Filus; Dylan Field (E) E. Denton; Eddie Major; Edie Levenson; Edward G. Sharp; Elana Pianko; Eleonora Ronconi; Elise M. Huston; Elizabeth Cerejido; Elizabeth Cowell; Ellen Bunch; Ellis Gross and Pat Pyle; Emily Maxwell; Eric Alan Solo; Eric Wolfram; Erika Turner; Erin Brethauer; Erin Rufledt; Estefany Molina; Esvan Rivera; Ethan Wolff; Ethan Zuckerman; Eva Kamp Jensen and Brian Rygaard; Evan Bachner; Evelyn Ringman (F) Fabien Hénocq; Fat Maggie Productions; Fawn Colombatto; Felix Glauner; Francis X. Melvin; Frank Rapant; Fred Benenson; Fred Bidwell; Frederike de Voogt; Fulvio Spada (G) Gabriel McIntosh; Gaby Clingman; Gaius Alexander Newland; Gardner Monks and Tasha Braga; Garrett and Jennifer Jennings; Gary C. W. Chun; Gary Gilbert; G. D. McClintock; Gene Sloan and Nicole Edmund; Geof Teague; Geoffrey Stern; George Campbell; George J. Renaldi, Jr.; George Slade; George Turner III; Georgia Landman; Gerd Rehse; Gerry M. Goldman; Gion Andriu Isenring; Goolius Boozler; Gray Harrison; Greg Beams; Gregor Hochmuth (H) Hank Sherman; Hanne Mintz; Hanno Mackowitz; Harriet Cavanagh; Heather N. Markway; Helen Ray Hua; Henry Horenstein; Hillary Bright; Horatio Baltz; Hye-Ryoung Min and Jaime Permuth; Hywel Jenkins (I) Ian van Coller; Isa Leshko; Isis M. Duran Hijaz; Izzy Morones (J) J. Cory Wright; J. Edwin Braley; J. Kevin Barton; J. Nordberg; Jörg Colberg; Jack and Aekyoung Large; Jack Meyer; Jackie Snow; Jackson Fine Art, Atlanta; Jacob and Melissa Proffitt; Jacob Krupnick; Jacqueline Prekelezaj; James Kozy; James Kralik; Jamey Brooks; Jamie McIntyre; Jan Stam; Jane Cunniffe Farkas; Jani Zubkovs; Janice Lipzin; Janique Helson; Jared Polin, FroKnowsPhoto.com; Jason; Jason Day; Jason DiOrio; Jason M. Paladino; Jean Marie Riquelme; Jeannine Zipfel; Jed, Laura, and Jane Northridge; Jeevan C. Gowda; Jeff and Melinda; Jeff Crisman; Jeffery Miller; Jeffrey Fischman; Jen Miller and Gabe Rhodes; Jen Scoville Strickland; Jenni Bick; Jennifer Green; Jennifer Sias; Jenny Thompson; Jeremy Sachs-Michaels; Jeromy Q. Coleman; Jerry D. Grayson; Jess T. Dugan and Vanessa Fabbre; Jesse G. Louis; Jessica Graham Nielsen; Jessica Scarlata; Jessica Walsh; Jessica Watson; Jessie DiBlasi; Jessie Goodpasture; Jewel Mari Mlnarik; Jill Downing; Jill Henken; Jim Vorwoldt, S.J.; Jimmy Manenski; Joan Melasky Blomquist; JoAnne Bouzianis-Sellick; João Henriques; Joe and Jeanette Leader; Joe and Cathy Fragola; Joe Putrock; Joel Cornett; Joerg Metzner; John and Samantha Oliver; John Alpine; John Armstrong; John B. K. Martinec; John C. Williams; John d'Addario and Richard Read; John Doe; John E. Suter; John Ellis and Mark Peoples; John K. Freytag; John Lelli; John M. O'Toole; John Malone; John Mannikko; John Renaldi; John Rigsbee; John S. Anderson; John Shannon and Jan Serr; John Vigg; John-Michael Foster; Jon Hynes; Jonathan and Stephanie Zita; Jonathan Scherzenlehner; Joni Sternbach; Jordan C. Ford; Joscelyn Meador; Jose Manuel Romera de Landa; Joseph Maida; Josh Housdan; Juan Carlos Muñoz-Najar; Judith De Wilde; Judith Elyn Walker; Julia C. Roberts; Julia Vandoorne; Julie Comfort; Julie Harty; Julie McDonald; Juliet Smith and Jeff Auer; Justin Hoch (K) K.W.; Kane Stewart; Karen A. Milton;

Karen Anne Smith; Karen Francisco; Karen Marshall; Karen Nickell; Karen Ruffini; Kären van der Veer; Karin Soukup; Karl Lew; Karl Peterson; Kate McGregor-Stewart; Katherine Tako-Girard and Daniel Girard; Kathlyn Horan; Kathy Bousquet; Katrina Cass; Keiko Morris; Keith and Betsy Fitzpatrick; Keith J. King; Keka Marzagao; Kelli Connell; Kelly Cressio-Moeller; Kelly Dickerson; Kelly Kristin Jones; Kelly Nunn Holdcraft; Kendra Ruby Masters; Kerry Cupit; The Kessler Family Foundation; Kevin Nicholson; Kim Meyer; Kimberly Fox; Kimmy McAtee; Kio Stark; Kozva Rigaud; Kristi Courtois; Kristin Anderson-Barrett; Kristin Smith; Kurt Simonson; Kyle Gouveia; Kyle Levien; Kyle McFarren; Kyle Ridolfo (L) Lane Driscoll; Larry K. Snider; Larry Kellogg; Laura Khoudari; Lauren Hermele; Lauren J. Bouton; Lauren, David, Elle, Ari, and Josie Felderman; Laurie and Steve McLaughlin; Laurie Sterling; Lawrence Shadbolt; Layne R. Tepleski; Leila Anderson; Len; Len Jacoby; Lesley A. Martin; Leslie Irish Evans; Libbet Loughnan; Linda Camplese; Linda Fiffer; Linda J. Foley; Linda Kaplan Kielek; Lindsay Allen; Lindsay More Nisbett; Lisa Evans; Lisa Mennet; Lisa Nicole Osgood; Liz Madans and Alice Poon; Loren Parisella; Loretta Rae; Lorie Novak; Lorinda and Alan Brandon; Lorne Resnick; Lucas Michael and Raymond Lee; Luke S. Barton; Lynn and Gary Cohen; Lynn Nottage and Tony Gerber (M) Mae I. Frankeberger; Magela; Maggie O'Connor; Mai Bri; Man+Hatchet; Marc Etkind and Dixie Ching; Marc Janks, WhoAreYouNewYork.com; Marc Metcalfe, MD; Marc Stevens; Marc-André Bourgault; Marcia Dedeaux; Margaret Andrews; Margaret Brown; Margaret Riley; Margo; Marguerite Warner; Mari Rutka; Maria Rocha-Buschel; Marie Forbes-Osborne; Marina Katz; Marina Liu; Marion Belanger; Mariquel; Marisa S. Meyer; Mark Allen; Mark and Mary Kay Baker; Mark J. Doddato; Mark Luckinbill; Mark Menjivar; Mark Pense; Mark Reichert; Mark Vollinger II; Mark Wainger and Rhoda Woo; Marsha Warren; Martin H. McNamara; Martin Lesinski; Marwan Marwan; Mary Beth Knight; Mary Celojko; Mary Pinto; Mary Pratt and Ian Stell; Mary Stover, in memory of Buster; Mathieu Leroux; Matt Ayotte; Matt Blum and Katy Kessler; Matt Harvey; Matt Mathai; Matt McDaniel; Matthew Borowick; Matthew Cox; Matthew Palm; Matthew Pillsbury; Matthew Pritchard; Matthew Sheyka; Max Sterling; Meagan Ziegler-Haynes; Meaghan Shubaly; Meg Birnbaum; Meg Lemke; Meg Strouse; Megan Matthews; Megan Mitchell; Mehdi Mollahasani; Melanie Sutherland; Mia McLaughlin; Michael Foley; Michael George; Michael Gottlieb; Michael Hoeh; Michael Joseph; Michael Keith Harris, Jr.; Michael Khadavi; Michael L. Brock; Michael Light; Michael P. McGregor; Michael T. Middleton; Michael Wichita; Michaela Boehm; Michel Dayez; Michelle Girard; Mik Cooper; Mike Garten; Milli Apelgren; Mindy Smith; Miyan Levenson; Mo Scarpelli; Monica Lo; Monika Merva; Monique Nicole Ferris; Monty Collins and Jerry Dark; Morten Fosselius Legarth; Ms. Shawn Rorke-Davis (N) n&d; Nadya Wasylko; Nancy Larrew; Naomi Lynne Siegel; Natalie A. Williams; Nate "Igor" Smith; Nate House and Alexandra Millar; Nathan Tammi and Elijah Jarmon; Neal Sperling; Nicholas Laudadio; Nicole Mirante-Matthews; Nicole Sharkey; Nicole Warwick and Thomas MacNeil; Niels Hooper; Niels Joaquin; Nina Berman (O) Oh Whanau—Christchurch, NZ; Ohad Mayblum; Oliver Nicholas; Olivia Beck; Ori Artman (P) P-51 Pictures; Paige M. Cavanaugh; Pascal Caillon; Pat Tally; Patrick Locqueneux and Olivier Chevalier; Patrick Wright; Paul and Gwendolyn Kelso; Paul Giguere; Paul Schneider; Paul Serotta; Paulina Schipke; Peggy Sue Amison; Pep Ventosa; Peter Gerhardt; Peter Jessup; Peter Rigaud; Peter Zellan; Phil Block; Philip Arthur Moore; Philippe Latour; Phillip Washburne; The Powell-Palm Family; Project Red Balloon; Purav Patel (Q) Quality Camera Company (R) R. Gerst and J. Porçarelli; Réco Thomas; Rachael Currie, NZ; Rafael Soldi; Rags and Angus Edward; Randy Nelson; Rebecca A. Stern; Rebecca Kuhn; Rebekah Prout Struthers; Reinhard Kressner; Rene Kelso; Renee Zita; Renée Warren; Rennie LeDuc; Rhea Allen; Rich Lo and Joe Mayock; Richard Baiano and Craig Tevolitz; Richard Burg; Richard Doyle; Richard L. Renfro; Richard Robertson; Richard Williamson and Allison Barnes; Rick Green; Riley W. Kaminer; Rita Amendola; Robert Doran; Robert J. Guijt; Robert J. Morrison; Robert J. Poole; Robert Landis; Robert Neil Snodgrass, Jr.; Roberta Seed; Robin; Robin Levin; Rodney L. Alderman; Romain Blanquart; Ron Zuckerman; Ronald Eliassen Hole; Roosevelt Grier; Rory Walsh-Miller; Russell, Madyson, and Wyatt Boyd; Ryan Mesina; Ryan Paternite; Ryan Stolte-Sawa & Myk Bilokonsky; Ryan Tse (S) Sabra Embury; Sally Clark; Sally M. Fulton; Sam Fox; Sam Gast; Sam Krasnik; Sandi Lovegrove; Sandra Hartwig Elwell; Sanghyuk Yoon; Sara Speer Selber; Sarah Wilson; Sarina Renaldi; Saul Zelan; Saundra and Charles Boyd; SAWA; Sayo Granich-Lee; Scott Kelly; Scott Sheldon and Barbara de Wilde; Sean and Alicia; Sean Murphy; Sean Newman; Selma Santos; Sera Morris; Seth Boyd; Seth M. Johnson; Shana Butcher; Shanda Swenson; Shane Lavalette; Shane N. Anderson; Shaun Talbott; Shelby Fischer; Shelly M. Mohnkern; Shen Wei; Sherri Wasserman; Siena Oristaglio; Silas Finch; Simon "Fettbemme" Welker; Simon C. Blakey; Sirenna and Emilio Palici; Siri Kaur; Sophie de Rakoff; Stéphane Castoriano and Daniel Ponton; Stéphanie Banzet; Stephanie Graziano; Stephanie Pereira; Stephen Dennison; Stephen I. Reinstein; Stephen L. Cohen; Stephen Voss; Steve and Cassie Kemple; Steve Chevalier; Steve Flores; Steve Soldan; Steven Sergiovanni; Stewart MacPherson Hunt; Stuart B. Cooper; Susan Bennerstrom; Susan Hartman McLaughlin; Susan R. Grossman; Susanne Kahle; Sylvain Selleger (T) T. G. Alt; Talmon Kochheim; Tamar Tesler; Tania Marchand, MD; Tara Fallaux; Terri Hannifin; Thad Allan Winkle I; theNewerYork.com; Thomas Adams; Thomas R. Anoe; Tiffany Jones; Tiffany Reid; Tim Burns; Tim Kroesbergen; Tim Rubans; Timothy Briner; Timothy Diliberti; Timothy Kudo; Tisha Taylor; To Rosemary, in memory of John Roach; Tom Whitney; Tom and Desiree Connors; Tom Claxton; Tom Jones; Tom Roberton; Tommy Mendes; Tony A. Watson; Torsten Pauer; Travis von Wächter; Tyler Berube (V) Valentino Gianuzzi; Valerie Piriak; Vanessa C. Steffen; Vanessa Vasadi; Vanessa Winship; Veronique Toully, Lara Nathie, and Enez Nathie; Vicki L. Boyles; Vicki Topaz; Victor Alcantara; Vincent Cianni; Vinita Mathur; Virgil DiBiase (W) W. M. Hunt; Wadley; Walt Wager; Walter Bazzini; Wanda L. Anderson and Jennifer L. Harris-Frowen; Wayne Ford; Wen Hang Lin; Wendy Dawn Swanson; Wessel + O'Connor Fine Art; Whitney Lawson; Wil-Dog Abers; William Chan; William Childress; William Greiner; William Hertlein; The Wilson family; Wyatt Guttenberg (Y) Y Shin; Yutack Gabriel Kang (Z) Zoe Glas

FRONT COVER: *Nathan and Robyn*, Provincetown, Massachusetts, 2012
BACK COVER, LEFT TO RIGHT: *Nicholas and Caleb*, Philadelphia, Pennsylvania, 2013;
*Jessie and Michael*, New York, New York, 2013; *Shalom and Jeff*,
Brooklyn, New York, 2013

*Touching Strangers*
Photographs by Richard Renaldi
Introduction by Teju Cole

Editor: Chris Boot
Project Editor: Katie Clifford
Senior Text Editor: Susan Ciccotti
Copy Editor: Madeline Coleman
Work Scholars: Ana Alvarez, Jessica Lancaster
Design: Namkwan Cho
Production: Matthew Harvey, Luke Chase
Color Separations: Robert J. Hennessey

First paperback edition, 2017
Printed by Midas in China
10 9 8 7 6 5 4 3 2 1

Library of Congress Control Number: 2013956760
ISBN 978-1-59711-430-1

To order Aperture books, contact:
+1 212.946.7154
orders@aperture.org

For information about Aperture trade distribution worldwide, visit:
aperture.org/distribution

**aperture**

Aperture Foundation
547 West 27th Street, 4th Floor
New York, N.Y. 10001
aperture.org

Aperture, a not-for-profit foundation, connects the photo community and its
audiences with the most inspiring work, the sharpest ideas, and with each
other — in print, in person, and online.

I would like to thank the following for their assistance, encouragement, and
support: Alexis Light, Andrew Sloat, Ann Pallesen, Annette Booth, Barbara
Escobar, Betsy Fitzpatrick, Bob Hennessey, Cory Jacobs, Diego Sierralta, Jason
Bailey, John Leland, Jörg Colberg, Katie Clifford, Kellie McLaughlin, Lesley
Martin, Matthew Harvey, Nelson Santos, Niko Koppel, Sarah McNear, Steve
Hartman, Bon Secours Community Hospital, Bonni Benrubi Gallery, Breakers
Bar, CBS News, Golden Cavvy Restaurant & Lounge, Jackson Fine Art, Koolsville
Tattoos, LTI Lightside, La Bonbonniere, Milford Laundromat, National Public
Radio, North Carolina Department of Transportation, Ohio State Fair, Octopus
Car Wash, Purdue University, Photographic Center Northwest, Robert Morat
Galerie, the Byodo-In Temple, Fondation d'entreprise Hermès, the Frick Collection,
Provincetown Inn, the Saugatuck Center for the Arts, and Third Floor Gallery.

Special thanks to Chris Boot who saw the potential in this work, and whose
advice and leadership helped challenge me to make better pictures.

Lastly, I am grateful to Seth Boyd who made a colossal contribution to this project
through his advocacy, council, and guidance. I dedicate this book to him.

*Richard Renaldi, New York, 2013*

touchingstrangers.org